JOHN BEARDSWORTH

101 TOP TIPS

FOR BLACK & WHITE DIGITAL PHOTOGRAPHY

JOHN BEARDSWORTH

101 TOP TIPS

FOR BLACK & WHITE DIGITAL PHOTOGRAPHY

I L E X

First published in the UK in 2012 by

I L E X

210 High Street
Lewes
East Sussex BN7 2NS
www.ilex-press.com

Distributed worldwide (except North America)
by Thames & Hudson Ltd., 181A High Holborn,
London WC1V 7QX, United Kingdom

Publisher: Alastair Campbell
Associate Publisher: Adam Juniper
Creative Director: James Hollywell
Managing Editor: Natalia Price-Cabrera
Specialist Editor: Frank Gallaugher
Editor: Tara Gallagher
Senior Designer: Ginny Zeal
Designer: Jon Allan
Colour Origination: Ivy Press Reprographics

British Library Cataloguing-in-Publication Data
A catalogue record for this book is available from the
British Library

ISBN: 978-1-908150-90-5

Printed and bound in China

10 9 8 7 6 5 4 3 2 1

Contents

1

Great B&W, whatever post-production program you use

Not so long ago, you didn't make a photograph black and white—you made a black-and-white photograph. That's more than a play on words. With film, you had decided early on that the picture was going to be black and white, and it was a decision process that began when you bought that roll of B&W film and loaded it into the camera. Other creative choices, like screwing an orange or yellow-colored glass filter onto the lens, were also made before you ever released the shutter. With digital B&W it's largely the opposite way round. You already have the photographs in their full color glory, and it's afterward that you make them black and white.

I mention this distinction because with digital B&W—as with many other things in life—it is rather too easy to be deterred by imagining everything you must do before you can get started. Hopefully this comes as a pleasant surprise, but put such doubts to one side. You probably already have what you need to get started with B&W.

Let's assume you do already have a digital camera. There are of course better cameras out there, some with features which may help you to capture new subjects or with more pixels and better color. Some advertise black-and-white modes too. You don't need them, and in fact you're better off not using them.

Equally, you will already have a computer. But you don't have to go and buy a Mac for photography, whether it's B&W or color. Do so if you want a good new computer, but good new PC will be fine too. It's more important that your computer, whatever it may be, is moderately powerful. You can always spend more, but nothing exotic is required.

What this is leading to is that this book will show you how to do B&W using Adobe's Lightroom, and a section will also be devoted to Silver Efex Pro (SFX), Nik's excellent dedicated B&W software. But that's because there's a good chance the kind of photographer who is likely to read this book will already use Lightroom or have friends using it. What we are really doing is using these popular apps to demonstrate the underlying principles of B&W. You may already work with Photoshop, Photoshop Elements, CaptureOne, Aperture, to mention a few good image-editing programs. Whichever program is your tool of choice, you should be able to apply the concepts we're going to show.

1–2 Don't let anything hold you back. You probably already have what you need to get started with digital black and white.

2

Appreciate
the heritage of B&W

1–2 Photography is a great excuse to appreciate our natural heritage.

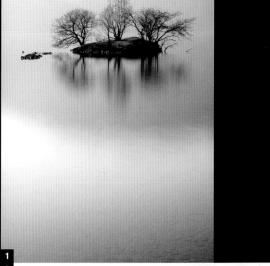

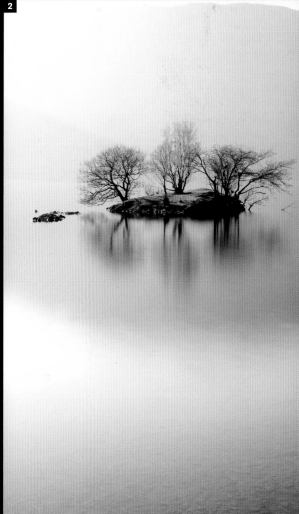

1
2

Admiring black-and-white photographs is often what first starts people out on their own road to becoming keen photographers. But even if B&W is new to you and you approached from another direction, learning to appreciate the art form's rich past and present is an excellent way to develop your own sensibilities.

There are many styles of B&W, from the luminous landscapes of Ansel Adams to the more nocturnal styles of a Jeff Kenna. If you're more of a people photographer, you might look at the gritty photojournalists or at high key studio portraiture, and of course there are many other categories of photography which B&W. It might seem trite to call this empowering, but if you don't know the possibilities how do you expect to reach them?

In the days before the internet one might have recommended an excursion to a museum or art gallery, and it remains a great way to progress. Standing close to a well-exhibited print is a richer experience much richer than seeing the same picture on a screen or in a book. Major national institutions may open your eyes to the dizzying heights, yet local collections and the subjects may be to which you can aspire.

Chapter_

Equipment
& Accessories

 8

 9

 10

 11

 12

 13

14

15

16

 17

18

19

20

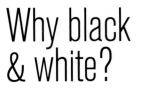

3

Why black & white?

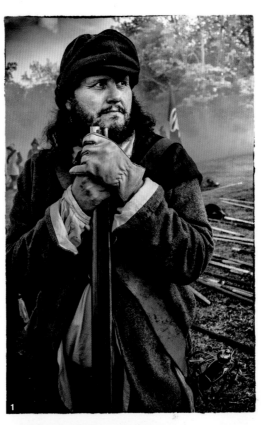

1 Public events are great places for pictures of people. Just ask permission—what's the worst they can say?

2 Many photographers feel no need for an artist's statement, but still have an underlying mission. My reenactment pictures come directly from a lifelong passion for history and a love of reportage photography.

It's always worth reflecting on why you are doing B&W. After all, making pictures black and white is a deliberate choice and there's usually a bit more to it than a whim.

One idea is to write down what you aim to achieve, and some photographers like to do this in an "artist's statement" which describes their creative goals. Sometimes they try to cover their photography as a whole, but others will write statements explaining a single project or series of pictures. Part of the attraction is that putting your thoughts in writing makes you think them through, and helps crystallize what were once vague ideas into specific steps and renewed motivation.

On the other hand, the artist's statement is often so pretentious that it opens the artist to ridicule, or is so badly written that it exposes why its author has chosen a visual art form. So you've got to be careful with your language!

But an artist's statement is just one idea—it's never a bad idea to question and define our own objectives.

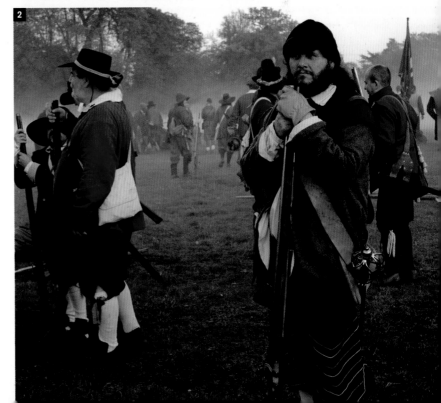

More than turning down the color

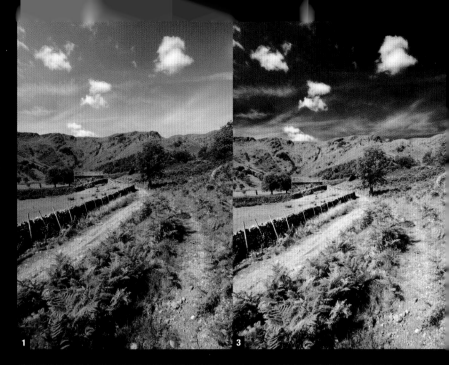

1 Just because a picture is colorful doesn't mean it won't work equally well in black and white.

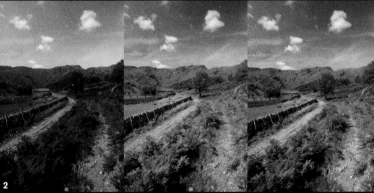

2 A color image is built from three distinct black-and-white versions.

3 The final picture uses the channels to express what you saw in the scene.

Some black-and-white photographers prefer their medium because they find color distracts from the picture's subject. The eye is drawn to reds and yellows, nature's warning colors, and before we examine what exactly is depicted, we are inclined to notice a rich blue sky or sense that the white balance is off. More than simply diverting us from what is actually depicted, a hardcore B&W enthusiast might even ask what colors actually add?

While the absence of color may contribute to our appreciation, at the same time it is important to assert that black and white is not photography minus color. Not at all. It's much more subtle than turning down the color saturation on your television.

To understand this key point, we have to think about the digital color photograph. It begins its life when the digital camera captures a scene as a grid of brightness readings. Usually laid out in patterns of four, two readings record values for only green light, one red, and one blue. This Raw data is then "demosaiced" in the camera or on the computer so that each pixel now contains three brightness values—red, green, and blue. We've effectively got three monochrome pictures, each slightly different.

Rather than simply removing the color, black and white is about carefully mixing these red, green, and blue "channel" values to make the final picture. Here is where we apply our skill and exercise creative control.

For example, this picture's three channels are very different. In the blue channel image, the sky is very light because there's lots of blue light there, while the landscape is dark because the dried grasses are in the yellow-orange range. Conversely, in the red channel, the sky is rendered a darker gray due that part of the scene containing little red light. As a result, the clouds stand out more too.

This is where the B&W worker introduces creativity. We wouldn't hit a "remove color" button, but we would think about our photograph and what we want its black-and-white version to express. Here we would make the most of the sky, and we might want to convey that it was a lovely spring day. So we'd seek to use more of the red-channel look in our final picture. To put it another way—every color picture contains a number of black-and-white interpretations.

5

Do you really need to "see" in B&W?

I've leafed through many books about digital black and white and have seen countless articles in magazines or online, and almost without exception they advise you to "learn to see in black and white." Sometimes this is described as the "key" to successful B&W—even "the secret," no less.

While it is an obvious topic for any book on the subject, I wonder if "seeing in black and white" has become a bit of a cliché—a sort of painting-by-numbers approach to teaching B&W. It's taken for granted that you should practice this peculiar skill.

The trouble is, the more I reflect on it the more I am convinced that people can do great black and white without "seeing in grayscale." What's worse is that far from it being "the secret" to great B&W, it's always a bit vague and impractical that I suspect it holds back their black-and-white photography.

One common suggestion is to find an orange or yellow colored filter, the type black-and-white film users would put on their lens. Look through the filter and see how it changes the relative brightness of different parts of the scene. I'm just not sure this is of great practical use though!

I wouldn't normally recommend using cameras' mono picture styles or modes. But one beauty of digital photography is the instant feedback, and some say it's helpful to see a B&W version on the camera's rear screen immediately after shooting the scene. I'm not sure it's useful however—alternative B&W treatments on your computer are more informative than a small LCD panel—but there's no

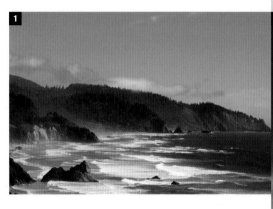

harm. Just remember to set your camera to capture Raw files.

Where you may gain some insight is by trying to ignore the colors and examining the scene for shapes and forms, textures, and compositional structures like leading lines. Look particularly for contrast between important neighboring details in what you're photographing, and in two distinct ways—brightness contrast and color contrast.

1–2 A good color picture is usually a good black and white too.

3–4 It's an obvious opportunity for black and white when a scene contains little color but lots of texture.

3

4

6

A colorful picture is perfect for B&W

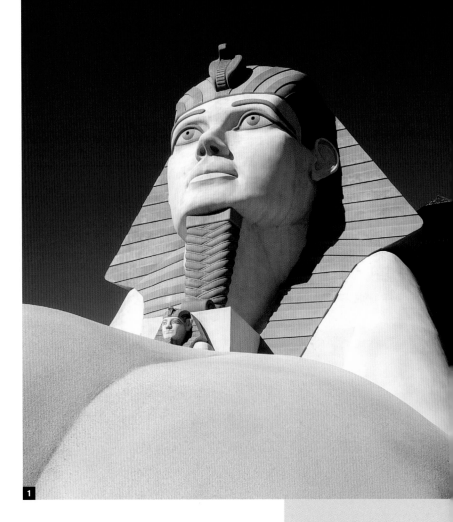

When people first think about black and white, there's usually a tendency to look at a scene and think of contrasts in brightness. Composing a picture, you notice some elements are brighter than others, and if you think ahead to how the composition will look in black and white you would naturally expect that such brightness variations would translate directly into distinct shades of gray. Turning that thought around, where there's no difference in brightness between the various elements of your composition, you would expect them to be nearly indistinguishable from each other when you convert the picture to black and white. We can easily appreciate the value of variations in brightness.

But color contrast is at least as important for black and white. Counterintuitive though it may seem, a very colorful scene can be perfect for a black-and-white picture.

We've already seen that a color picture consists of a grid of pixels that each have red, green, and blue brightness values. When combined, these three monochromatic channels make a color picture; but we can also use them separately. Essentially, lurking inside every color picture are three—or more—black-and-white versions.

This sphinx might seem the kind of picture that belongs in color. The sky's rich blue is echoed in the headdress's stripes where there's a complimentary golden color. But it is exactly this color contrast that makes this picture an ideal opportunity for B&W.

In black and white we gleefully exploit these color contrasts. We wouldn't waste our time with the green channel version here. While it's OK overall, what's missing is obvious when you look at how the blue and red channels render the stripes. They are much more obvious in the black and white, adding some drama to the picture, and secondly the different grayscale shades now convey to the viewer that the stripes alternate and may not be the same color or material. So a color contrast allows us both to fine tune the black-and-white version's composition and choose a creative interpretation of the scene.

1 Great color contrasts are great material for black and white.

2–3 In the red and blue channels, the contrast in color between the stripes is obvious.

4 In the green channel, the stripes all look the same because they were roughly the same brightness.

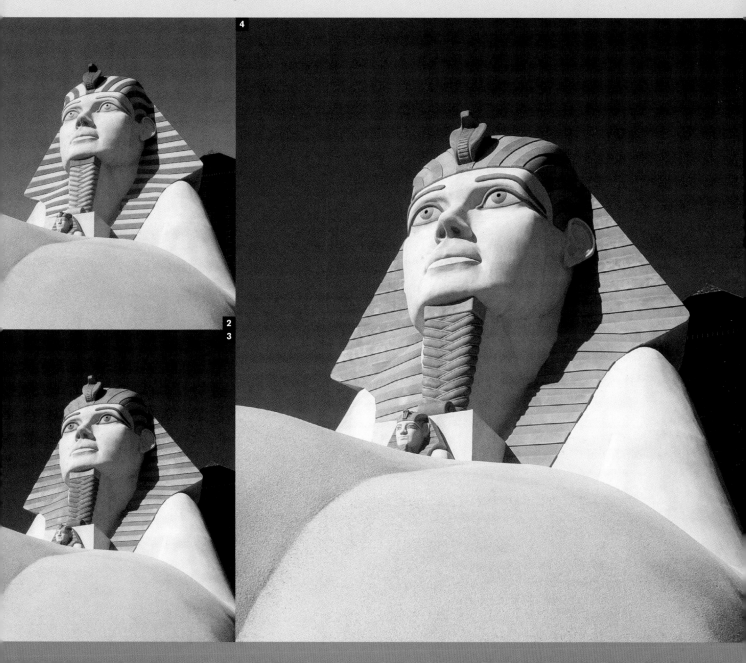

7

There's no such thing as bad weather

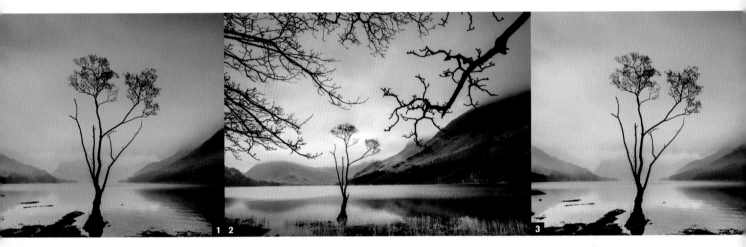

Color contrasts offer ideal raw material for black and white, and provide opportunities to create a range of interpretations. We can certainly appreciate a beautiful day as much as any photographer. But we obviously don't depend on color to the same extent as the dyed-in-the-wool color enthusiast who might take one look at the weather and dismiss it as a good day for black and white. Of course, as a friend of mine says, there's no such thing as bad weather for photography, just a bad attitude.

So if we're composing a picture and trying to think in black-and-white terms, we need not be deterred by a lack of color contrast. In fact, on a horrible gray day, it's probably easier to imagine the final black and white. We just have to go looking for contrast in the brightness of elements in the composition.

Take this lakeside scene for example. I've seen many similar versions of the tree and almost all the best are in black and white—usually in mist or the rain. On a clear day, the tree tends to match the hills at the other end of the lake and no longer seems to stand in isolation. You can see that in the view taken through other branches. The tree's trunk is fighting the dark bit of lake shore directly behind it. But on a similarly gloomy day, mist or rain softens the background and provides tonal separation. You can see this in the drab color version, and easily imagine how a black-and-white picture may appear.

1 There's no such thing as bad weather for photography—just a bad attitude.

2 When things get in your way, put them to work and make them part of the composition.

3 Use bad weather to your advantage—it often makes the foreground stand out.

8

Shoot Raw, not JPEG

1 JPEGs can be great directly from the camera.

1

If your camera can capture images in a Raw format and you're serious about your photography, you probably know already that you should switch on that option. It's good advice for any serious photographer, but there are particular reasons why it's important for black and white.

When any digital camera captures an image, it first records Raw data in its own proprietary data format. When set to a JPEG mode, the camera then processes this data and saves a JPEG file to its flash card. Since JPEG is a well-established type of file, this picture can then be read by any computer, smartphone, or tablet and printed, emailed, or shared online. It also takes a lot less disk space than the Raw data.

So what is there not to like? Well, the camera's built-in software creates the JPEG to specified quality settings and dimensions. It has a lot more Raw image data than it needs, so even if you choose a maximum size and high-quality JPEG setting, a lot of the Raw data is simply discarded and is gone forever. The JPEG is optimized, compressed, or "lossy."

Because the image data contained in a JPEG is so much less, you have less latitude in post-production. The more you try to adjust it, the higher the chances are that image quality is going to suffer. With a Raw file, you can squeeze out that last bit of quality.

2 However, JPEGs can also let you down when you work on them. I adjusted the picture's contrast too much and the tonal gradation in the sky has begun to break up or "posterize."

3 After making the same adjustments to a Raw file, there's now smooth gradation across the sky.

2　　　　　　**3**

9

Camera monochrome modes

Nowadays, cameras are packed with features, and B&W or monochrome modes are very common. They allow you to set the camera so it creates a black-and-white picture and then review it on the LCD panel immediately after taking it. While this can be informative, there are one or two downsides.

If you decide to shoot JPEG, you're better off shooting in color. Your camera's B&W modes can certainly create a decent quality black-and-white jpeg and also provide some creative control—usually choices like "red filter" or "yellow filter." So you're not entirely surrendering your creativity to a software engineer's assumptions. Nevertheless, a B&W JPEG does significantly limit your creative flexibility down the line. The camera throws away all the color data when it bakes the B&W JPEG, so you can never print a color version of the photo or use the red, green, and blue channels to fine tune a black and white. If you do prefer JPEG, take the picture in color.

Monochrome modes are much less limiting if your camera is set to Raw format. The camera will save a Raw file which consists of the original color data in its entirety, some proprietary B&W-processing instructions, and also one or more B&W thumbnails.

Because all the Raw image data is preserved, you retain complete flexibility to produce color and a range of B&W interpretations of the picture. That's good.

The B&W processing instructions are only relevant if you use the camera maker's own software to process the pictures.

Also in the Raw file are one or more B&W thumbnails. The camera displays these on its LCD panel, and they may also be available on your computer in Windows Explorer or Apple Finder, for example. There's no doubt that seeing a B&W picture on the LCD panel does help some people imagine what the final B&W picture will look like— for instance: Are important elements distinguished from each other? But remember the LCD panel is only one of the many possible B&W interpretations that you can create from the picture.

So there is something to be said for using your camera's monochrome modes in conjunction with Raw formats. Don't be afraid to give them a try.

1 Nikon calls them "picture controls," Canon "picture styles;" but most modern cameras let you apply built-in looks to your Raw files.

2 If your camera provides picture styles, it will certainly offer black and white as a choice.

SHOOTING MENU

NEF (RAW) recording	
White balance	AUTO
Set Picture Control	MC*
Manage Picture Control	––
Color space	Adobe
Active D–Lighting	OFF
Vignette control	ON
Long exp.NR	OFF

Set Picture Control

SD Standard	
NL Neutral	
VI Vivid	
MC Monochrome*	OK

Grid Adjust

10

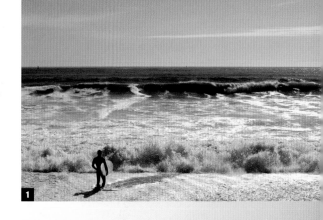

1 A sepia tone can often lend a timeless quality to a picture.

2 A cyan or blue tone can be brutally cold.

You've shot Raw with a monochrome JPEG— what next?

So your camera is set to capture images in Raw mode and you're using one of its mono modes or "picture styles." It can certainly be very informative to see the results on the camera's LCD panel immediately after taking a picture, especially when you're just getting to grips with black and white. Are the elements of the composition distinct, or do they appear confused? In a portrait, how do skin tones look? Or in a landscape, do clouds stand out or does the sky appear washed-out? Instant feedback is one of the great things about digital photography.

While seeing results immediately is fun, it's also an opportunity to learn and refine your technique. Cameras which offer picture styles usually include a range of black-and-white "filter effects." Sometimes these are labelled "landscape" or "portrait," but often you'll often see terms like "red" or "yellow." It's also common to see mono picture styles which add a little sepia or blue toning.

You don't really need to understand the underlying principles, but these colors correspond to the red or yellow glass filters that photographers put on their lenses when shooting black-and-white film. This allows them to control how the scene's colors are recorded on the negative. If you know something about black-and-white film, these terms make the transition to digital a little easier.

Do take time to try out these alternative filter effects. For example, shoot the same scene with each color setting, and then compare the different versions on the back of the camera. Notice how the

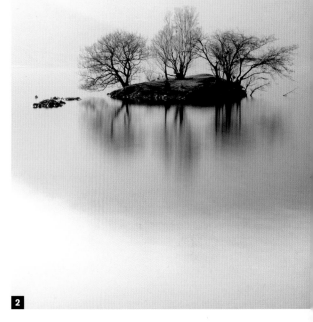

red style will darken blue skies and lighten skin tones more than its orange or yellow alternative. You'll soon learn that this different behavior is a key concept in B&W.

Of course, in the heat of the moment you won't always have an opportunity to shoot all these alternative treatments. When you are shooting in Raw format, it's more important that you get the picture than fussing around with the LCD panel. Choose one mono picture style, or just shoot color. As we'll see, once you have the Raw file on your computer, you'll be able to produce a range of alternative B&W interpretations.

3 Usually you can choose to imitate a B&W lens filter—here Y stands for "Yellow."

4 Toning is often available as well, especially sepia.

11

Advantages of picture styles

1–2 By choosing the Raw format, you can always ditch the picture style and produce a color version.

Apart from the instant feedback, another reason why you might use monochrome modes and shoot Raw is because it can reduce the amount of work you have to do on computer. Of course, that sounds good, but it's never so simple.

Let's consider what happens when you shoot Raw and use one of these modes. As well containing all the original capture data, the Raw file records the "picture style" you selected—in this case a mono treatment. Put another way, the Raw file is not really black and white. It is the complete color capture tagged with a marker to indicate how that data should be processed on computer.

These processing instructions are proprietary and are only recognized by the camera maker's own software. Nikon Capture NX or Canon's DPP, two of the best known, can produce a picture which exactly matches the in-camera black-and-white picture style. If, for instance, we shot the picture on a Nikon and chose the camera's sepia-toned style, as soon as we opened the picture in Nikon Capture we would see our sepia version.

The camera makers' programs will let you adjust the Raw files, if you wish. So you can fine tune the black-and-white treatment or even go back and produce color versions. But if you do not want or feel a need to adjust the pictures, you can print them immediately, send them to Photoshop, or share them online or via email. They should look the same as on the back of the camera.

This is obviously convenient, and the camera

makers' programs can certainly produce excellent quality. On the other hand, some might say that camera makers are better at designing cameras and their desktop software is not to everyone's taste.

If you're serious about your photography, make sure you do use your camera's Raw-format option. In addition, consider using your camera's monochrome picture styles because they are handy if you want to review the B&W immediately after shooting, and they can help you learn what works in B&W. Lastly, you can cut down the work you do on the computer to produce black-and-white photographs, while keeping all the benefits of shooting in Raw.

3 Nikon's Capture NX or Canon's DPP can identify the picture style set in the camera.

4 If you must have JPEGs immediately, consider shooting Raw + JPEG. It may be twice as many pictures to manage, but you're not sacrificing quality.

12

Shoot first and make the creative technical decisions later

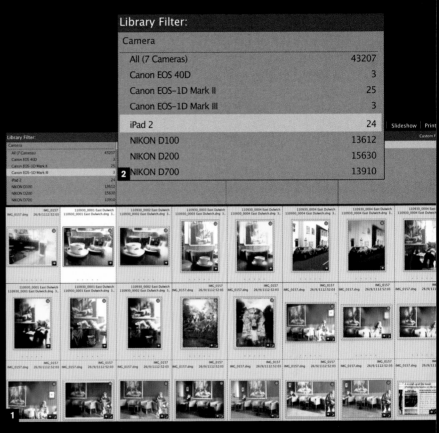

Choosing one of your camera's monochrome picture styles does not force you to process Raw files with the camera maker's own software. Doing so can offer some benefits, but is only one option. What happens if you don't use the camera maker's software?

Other programs like Adobe Lightroom or Photoshop will happily process your Raw files. What they can't do though is understand the monochrome picture styles because these processing instructions are proprietary to the camera manufacturer and are not publicly available. As a result, when Lightroom opens a Nikon or Canon Raw file, for example, it displays it as a color picture—Lightroom has no way of knowing that you chose a black and white, sepia-toned style. It's up to you to use Lightroom's tools to make the picture black and white.

Does this really matter though? Should you then avoid monochrome picture styles if you intend to use Lightroom, Photoshop, Aperture, or Capture One, or any other software?

The answer, you'll be pleased to hear, is that most photographers are unconcerned by this. Granted, you do need to do a little work on your computer to make the picture black and white—but that can be as trivial as clicking a button and choosing a preset. It may also be a little inconvenient if you can't remember exactly which pictures you planned to make black and white.

On the other hand, specialist image-editing programs like Photoshop, Lightroom, Aperture, and

Capture One software offer slicker workflow, greater ease of use, and more powerful features.

Another reason for not using camera makers' image-editing programs is that over time you may own cameras from more than one manufacturer. You may have a digital SLR and a high-end compact camera that can also shoot Raw files, or alternatively you may change your brand of camera. Instead of needing to learn each camera maker's software, it's great to learn one program properly and use it to process all your work.

1–2 With third-party programs like Lightroom, Aperture, and CaptureOne, you can program them to work on pictures from any camera maker.

13

Review exposure with the histogram

It makes sense to use your camera's LCD panel to review pictures as you take them—if not after every exposure, then every so often. As well as being sure you captured what you wanted, and perhaps assessing a B&W treatment, you also want to be confident about the exposure. But why is this, what do you aim to achieve, and are there special concerns about exposure for black and white?

Modern cameras' metering systems are amazing and highly reliable, removing much of our need to think about exposure. But not all. They can be fooled, because they necessarily include certain assumptions about brightness.

At one extreme, where a subject is close to white, the camera would normally tend to underexpose and make it appear darker. It doesn't know that it is capturing a snowy landscape for example, but assumes the scene is of average brightness—i.e., a dull gray. Left to itself, the camera would reduce the exposure to try to make the picture reflect its assumptions. With film, a photographer would need to know before pressing the shutter release that it would be necessary to compensate for the scene's unusual brightness by increasing the exposure by +1 or +2 stops. The digital photographer can review the LCD panel on the camera's back, see what's gone wrong, and make a similar correction.

At the other extreme, the camera would tend to overexpose a very dark subject. It's as if it wants to compensate for the lack of light, and the result is

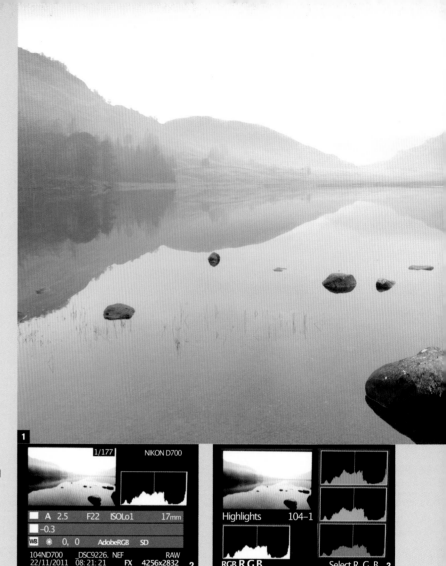

that it makes a dark scene or subject appear much too bright. The photographer would compensate for this by reducing the exposure. Again, the LCD panel's instant feedback is a huge advantage of digital photography.

The panel's histogram option takes this to another level, and it's not hard to learn how to use it. At its simplest, it shows how many pixels are at each brightness value. On the left are black tones, and white is over to the right. An "ideal" histogram would show that the pixels' brightness values are distributed between the extremes. As we'll see, what we would generally want to avoid is spikes at either end.

1 Straight from the camera, the risky area is the sky, which looks a bit brighter than the rest of the picture.

2 The camera's histogram shows many pixels are at each brightness value.

3 More advanced histograms break down brightness by channel. Here blue is slightly more to the right—brighter—than the other channels.

14

Protect the highlights

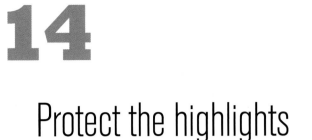

1 A spike on the histogram's right is a sure sign of overexposure and blown highlights.

2 Programs like Lightroom can reveal detail in the brightest highlight areas, but also warn you when they are beyond repair.

3 Overexposed areas merge away into the paper on which the pictures are printed.

4 We, as viewers, intuitively know there must be detail in these overexposed areas.

Looking at the histogram on the camera's back, the black-and-white photographer needs to pay full attention to what's going on at its extremes. It's these areas where a poor exposure can be most damaging. The tones that lie between the whites and the blacks can be fine tuned and made a touch darker or lighter, but there's no easy road back if you have "blown highlights" or "blocked shadows"—areas where there is no visible detail.

Thinking first about the highlights, you can recognize a potential problem if you see a significant spike at the histogram's right. What this is telling you is that the exposure contains a lot of pixels whose brightness reading is pure white. Put another way, those pixels are so bright that there is no detail there.

When these bright pixels are clustered together, those parts of the frame end up as areas of blown or "burned-out" highlights. While that doesn't necessarily ruin every picture, large blank patches can be distracting and detract from the picture.

With black and white, consider the importance of the highlights. More than with a color photograph,

the eye tends to be drawn from the shadow tones and to its brighter areas. If these are empty, we quickly sense something is wrong. We know, for example, that fluffy clouds contain a variety of shades and are not pure white blobs. Similarly, a white wedding dress usually contains subtle detail which we would usually wish to show in a photograph. Also think ahead to when the picture is printed. Where the print has a border, blank white areas near the edges lead the eye out of the picture and spoil its neat rectangular form. It's also possible that the printer may not lay down ink in blank areas, so blown-out highlights may sometimes become noticeable on the paper's surface.

The bigger the spike at the right end of the histogram, the more pixels contain no detail. Answer: Reduce the exposure.

15

Set your camera's highlights alert

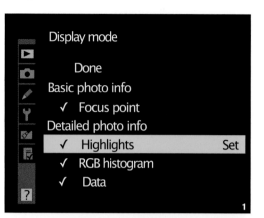

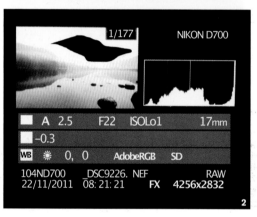

There is a problem with continually reviewing the LCD panel histogram—it's not as much fun as seeing the photos. Viewing the histogram usually means displaying the picture at such a small size that it can't be evaluated, so you have to scroll the panel between the different views. More expensive cameras often make available separate red, green, and blue channel histograms, in addition to the combined RGB view. Unless you are technically-inclined and interested in the data, how much detail do you really need? Do you even need to see the histogram?

Fortunately, most digital cameras offer a great alternative—a "highlights alert." Usually, this is an option which you can activate somewhere in the LCD panel's menu. It's well worth trying, and for what it's worth it is my preferred way to set up my own cameras.

The idea is that most of the time you switch on the camera's LCD panel to review the photo, not its histogram. You only want—or need—to be told when something may be amiss. So when the highlights alert option is enabled, the camera detects highlights which may be overexposed and blinks or flashes those parts of the photo.

While the highlights alert shows which parts of the image appear to contain blown highlights, it doesn't tell you how much you may have overexposed, or what you might do. Should you adjust the exposure bias by -1 or -1/3? You may wish to switch to the histogram for more clues. A lot

1 Every camera is different, but look through the options menu for a highlights alert.

2 The highlights alert flashes parts of the frame that are burned out and is a quick indication of a problem.

of pixels over on the right—a slope rather than a spike—would usually indicate that you need to reduce the exposure by a greater amount.

Alternatively, you may just prefer to reduce exposure by -1 or -2, repeat the picture, and then review the LCD panel again.

It is also worth emphasizing that these highlights alerts tend to err on the conservative side. If the camera is set to JPEG mode, the blinking highlights may well be completely overexposed, but Raw files may contain detail in those areas. Take the picture again, if you wish, but it may be best not to delete photos until you've had a chance to review the blown highlights on the computer.

16

The shadows

1 The color picture shows large areas of blocked shadows.

2 Blocked shadows don't always ruin a picture, but can certainly make it unattractive.

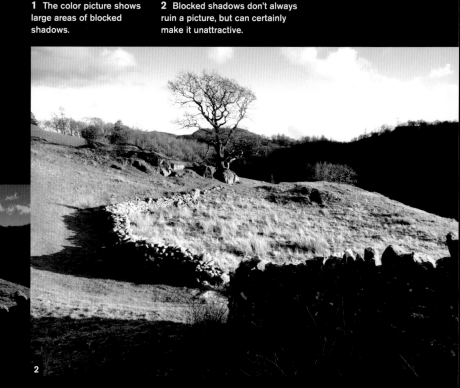

1

2

Turning now to the shadows, a spike to the histogram's left happens when a significant number of pixels have a brightness reading of zero or pure black. In small numbers, these blacks would be no problem and would "anchor" the image, helping to provide a good range of contrast. But if there are so many of these pixels that they are showing up as a spike, the picture will probably contain areas of dense or "blocked" shadows with no usable detail. Quite possibly, you've underexposed.

Are blocked shadows as damaging as completely burned-out highlights? Probably not. While an absence of highlight detail in clouds looks wrong or is really undesirable in a wedding dress, we are pretty accustomed to being unable to distinguish details in darkness and shadow. We wouldn't usually be as concerned about blocked shadows as about burned-out highlights.

A significantly underexposed picture will certainly appear unpleasantly dark on the LCD panel. We would be able brighten it up afterward on computer and interesting detail might be revealed in

the shadows, though nothing will have been captured in those parts of the frame which are completely blocked. Would we want our final picture to contain large areas of pure black? Sometimes we might, but more often we would want there to be at least some interest in the picture's darker shades.

When the histogram shows that the highlights are not burned out, we could add some exposure compensation and repeat the photograph. But if the highlights are already nearly blown-out, we could often choose to leave the exposure as it is and let the shadows look after themselves.

Another important reason for avoiding underexposure is that the shadows may contain unacceptable amounts of digital noise—a grainy and colored speckling caused by a low signal-to-noise ratio coming from the imaging sensor. When we brighten an underexposed image, we may make this noise much more noticeable to the viewer, and while programs like Lightroom can counter this degradation of image quality, it clearly makes sense to avoid the problem in the first place.

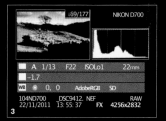

3

3 A spike at the histogram's left indicates possible underexposure.

17

Are lens filters still important?

In the days before digital, lens filters used to be the key to black-and-white photography. The principle is that red or orange glass reduces blue light reaching the negative, so those would be the color of the filter you would put on your lens to make the sky appear darker in B&W. A green filter would lighten foliage, blue might be the choice for grittier skin tones, and so on. All this knowledge is not dead, and you sometimes hear digital photographers talking of a "red-filter" look. But are such "contrast-control" filters still important for digital black-and-white photography?

One idea is that you can find a colored lens filter and hold it up to your eye as you study your subject. It's something black-and-white film photographers would often do as they consider which filter was most suitable, and the idea is that it will allow those with digital cameras to "see in black and white" too. But is there really any point carrying around these filters when your camera already has a set of mono picture styles? Of course not, not least because these styles are usually named "red" or "yellow" and are designed to reproduce the results of colored glass filters. You may as well use technology!

Even more ingenious is putting a colored filter on the lens and then shooting with a mono picture style. The trouble is that the sensor isn't capturing a black-and-white image. Usually the pixels are in groups of four—two green, a red and a blue. So if you used a red lens filter, for instance, it would block light to blue and make it darker, while lightening the red reading. The capture will normally be grainier or noisier.

Don't be deterred from using a colored lens filter—just use it on a camera that's loaded with black-and-white film.

1 Black-and-white film users place colored glass filters on the lens to control the color of light being recorded on the negative.

2 Digital cameras style monochrome modes on tried-and-tested methods.

3 Colored lens filters prevent light reaching the sensor's photo cells and produce a grainier picture.

18

Learn to use grad filters

1 Square grad filters offer the most flexibility. They fit into a holder attached to the lens by an adapter.

2 You need one circular lens filter for each lens size.

3–4 Try photographing the same scene with and without a grad filter.

Particularly if you enjoy photographing landscapes, one lens filter that may greatly benefit your black-and-white work is a "neutral grad." This type of filter is clear at the bottom but gradually darkens to a neutral gray at the top, and is used to balance the exposure of a scene without the sky's highlights blowing out.

The difficulty is the great difference in brightness between the sky and the land. This can easily exceed the camera's exposure latitude—the range of brightness values that sensor can record in a single capture.

So in some circumstances the camera's metering may expose the landscape well, but parts of the sky will be blinking on the LCD panel. Alternatively, the metering may treat the sky as the subject and set the exposure to capture it properly, resulting in a dark, underexposed landscape or subject. A neutral grad filter darkens down the sky, making it easier for the exposure to capture detail in all parts of the frame.

Neutral grads vary in strength—their darkness—and they also in "softness" or how quickly the graduated area goes from clear to dark. The softer they are, the less the chance that they will become visible as a gray line across your picture. This is unlikely when the aperture is open at $f/2.8$ or $f/4$, but becomes a risk when using a small aperture like $f/22$ or $f/32$ to maximize depth of field. The neutrality of gray can vary too, which is more of an issue for color pictures but is one reason why they vary in one other aspect—price.

The key to using neutral grads is subtlety. Look through the viewfinder and position the filter so the graduated area is above the top of the frame, then slowly move it downward until it is just visible. Sometimes you may have to move it down to the horizon, but not always, so take your time—and take more than one exposure and review each one on the LCD panel. With a little bit of practice, you'll soon have your blown highlights under control!

19

Other filters

1

1 Polarizing filters should be in every camera bag, though they are probably less use for black and white.

Neutral density filters

The purpose of a neutral density or ND filter is to reduce the overall amount of light passing through the lens. As a result, the shutter has to remain open for longer, so you can capture moving objects with a wide variety of creative effects.

ND filters are a neutral gray and come calibrated in stops. A two-stop ND would halve the amount of light and then halve it again, meaning the exposure would be four times as long as without the filter. Stronger ND filters can turn a 1/15 second exposure, which you would struggle to take without shaking the camera, into one that lasts four minutes.

Technique and equipment are important. Ideally you want a tripod and a cable release, and smaller apertures reduce the light still further and produce even longer exposures. Once you go beyond a fraction of a second, running water becomes blurred, while waterfalls turn silky smooth at between two to eight seconds, and waves turned to mist. Clouds and trees move, and you can reduce people and passing vehicles to a blur. ND filters are simply fun.

Polarizing filters

Polarizing filters limit the amount of reflected or polarized light that can pass through the lens. So you can use them to cut down reflections—something that has both pros and cons. In the sky, haze is reflected sunlight and a polarizing filter can eliminate this to produce punchy dark blues and puffy clouds which look just as good in black and white. But in other circumstances, a polarizing filter can make the image less interesting. Eliminating the light reflected off trees and other foliage can produce richer greens, but for the black-and-white worker this absence of reflections can become a deadening loss of tonal variety. So as you look through the viewfinder and rotate the filter, notice how it beefs up the colors, but don't be seduced—be cautious if it deadens the picture.

One other point is that polarizing filters are also weak ND filters and can be employed in the same way to blur moving objects.

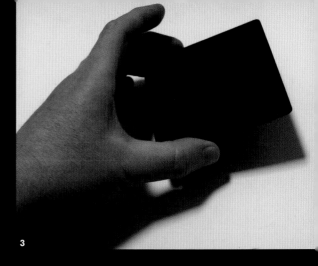

3

2 This is the result of using a ten-stop ND filter—a two-minute exposure.

3 Extreme ND filters are almost black.

20

Consider
HDR techniques

1–5 Faced with a huge range of contrast between the valley and the clouds, I quickly shot a series of exposures.

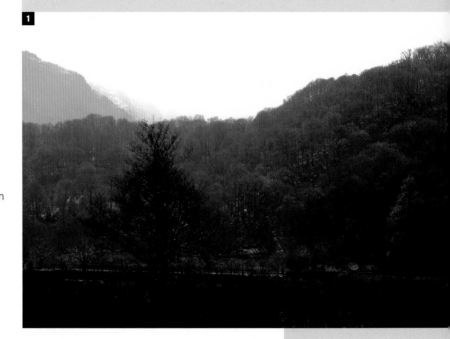

When a scene contains very great differences in brightness, a technique worth considering is HDRI or "high dynamic range imaging." This is both a technique and a style in its own right, with fans and detractors in equal number, and essentially means taking two or more exposures with at least one properly exposed for the highlights and another capturing detail in the shadows. These are then merged on a computer into a single picture.

In fact, some newer cameras actually offer a built-in HDR feature. You press the shutter release once and the camera makes a series of exposures and blends them together—though usually as a JPEG rather than a Raw file.

But let's assume your camera doesn't do it all for you. Ideally, each exposure would be identically composed, which will be easiest if the camera is on a tripod, but HDR software can often do a great job of automatically aligning frames if you need to hold the camera in your hand. Switching your camera to manual focus mode can help here too.

Working quickly will help reduce any chance of "ghosting" or other oddities caused by trees or clouds moving between exposures. Set each exposure one or two stops different from the previous exposure—very easy if your camera has an autoexposure-bracketing feature. Three frames are usually enough, but more won't hurt. Just review them on the LCD panel and ensure you keep enough frames to cover the highlights and the shadows.

Take a little care once you get the Raw files on your computer. When you're reviewing pictures and deciding which are worth keeping, it's very easy to see a poorly-exposed frame and delete it—forgetting you shot it as part of an HDR sequence. One idea is to identify these groups of pictures as soon as possible and do something like stack them in Lightroom, applying a colored label as a warning. This certainly is not foolproof, just one possible precaution.

Blending the individual frames into a high dynamic range picture is done automatically. Photoshop can do it, or you can choose a dedicated HDR program like Photomatix.

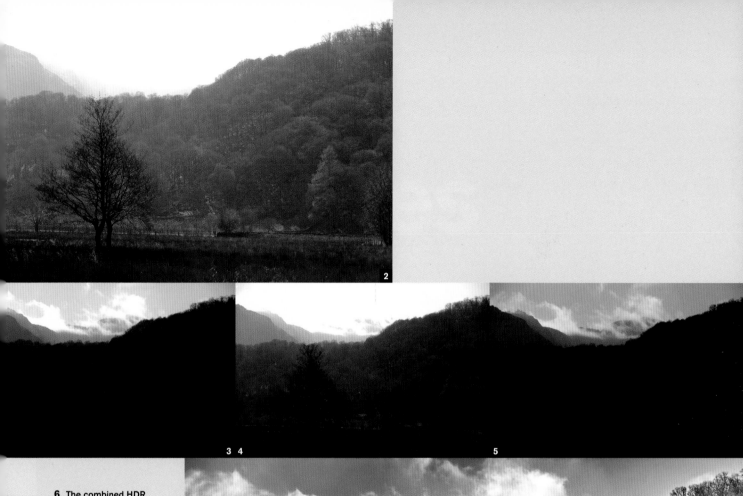

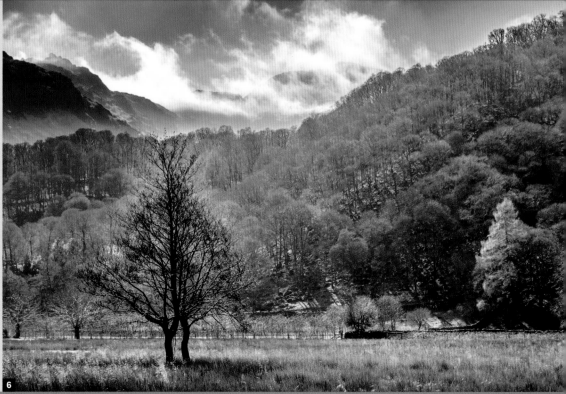

6 The combined HDR image contains detail in both the clouds and the shadow.

6

21

Choose your weapon

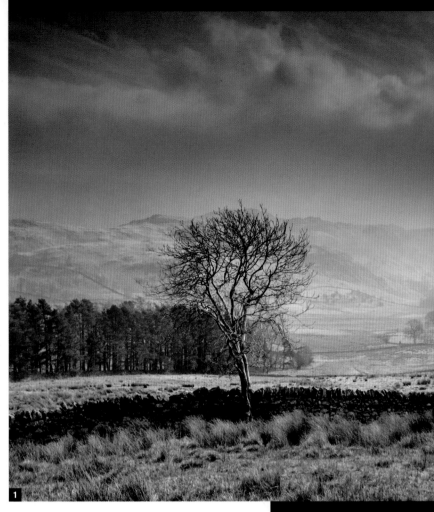

While B&W JPEGs can be printed or shared straight off the camera, with Raw format you're sacrificing convenience for the consistently better quality you can achieve by adjusting your pictures on computer. But again there's a decision to be made—which image-editing program should you choose? After all, there are alternatives which you can download and try for up to 30 days, but it's going to be hard to become productive with more than one, so how do you decide?

If convenience is uppermost in your mind, certainly consider using the camera makers' own programs. These pick up any custom settings such as a B&W picture style set by the camera, so you would only need to open a Raw file in Canon DPP or Nikon Capture NX. You could then print or email a JPEG version. For convenience, these programs can be a good choice.

On the other hand, some might say the camera makers are better at creating cameras and lenses and software companies produce better image-editing programs. This often comes down to how we each define "better," and that's never going to be a simple or straightforward process.

Ease of use is one area where companies like Adobe are well-regarded, but it is clearly a matter of individual preference. You'll never know if a program is right for you until you download it and get your hands dirty. A tip is to give each program a few days—no speed dating!

Don't be misled by how your pictures look when you first open them in a program. Initial appearances can be misleading and often reflect how far the software developer wishes to provide a pleasing default or a flatter treatment that doesn't presuppose how you might want the final image to look. What counts is not how the picture looks at first—that's just a starting point.

Image quality is on obvious criterion, and you might base your choice on reviews and head-to-head comparisons. Inevitably, there is some subjectivity, and often a superior capability in one program is offset by a relative weakness in another feature. What's more, in skilled hands, the differences can be very small indeed. How easily do you think you could get up to speed?

Other factors matter too. How helpful are the program's online tutorials, and what do your photographer friends use? Don't be afraid to strike out on your own, but we often learn well together.

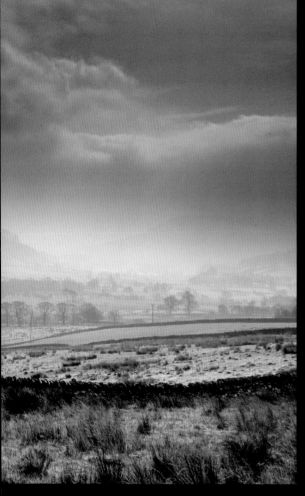

1 In skilled hands, all modern programs are capable of quality results.

2 CaptureOne is a highly regarded Raw processor.

3 Adobe Lightroom and Apple Aperture catalog as well as adjust your pictures.

4 The camera makers' programs like Nikon's Capture NX and Canon's DPP offer a high level of convenience, while lacking some of the more powerful tools offered elsewhere.

22

Adjust your color picture properly before going onto B&W

The latest software, like Lightroom, is generally quite forgiving and will let you work in whatever order you choose. If you really want to open your pictures on the computer and immediately make them black and white, you can certainly do so. Try to take your time though.

It's important not to forget the boring things. I won't belabor the point, but you should be certain every picture is safely backed up onto another drive, and remember that most image-editing software lets you enter keywords and other metadata for the very good reason that in the long run it is good for you—the less time you spend finding pictures, the more time you'll have to be creative.

But getting back to black and white, it makes sense to get the color picture right first before you start working in monochrome.

Some adjustment work is essentially about correcting the basic picture. Tasks like cleaning up sensor dust spots or fixing a wonky horizon will need doing at some point, whether you make the final picture color or black and white. Doing these jobs first, while the picture is in color, has a few advantages.

While you are correcting the capture, you're also looking closely at it and giving yourself time to think. Because of this, you will often pick up important color contrasts, or appreciate detail that is hiding in the picture's highlights and shadows. These may be quite obvious in color. But whenever you switch to black and white, there is a good chance that these subtleties will be lost in the initial "default" mono treatment.

Secondly, a big advantage of digital photography is that you have the freedom to produce alternative versions—a color version as well as a black and white. It's better use of your time to do the corrections before making separate versions.

So work on the color picture and get it as right as it can be. Correct its white balance, if needed, and clean up any sensor dust spots, rotating and cropping, capture sharpening, noise reduction, perhaps even lens distortions and aberrations. Be patient.

1 The finished image.

2 Lightroom and Aperture catalog your work, so here it took little time to sort through tens of thousands of pictures.

3 Correct the color picture before making it black and white. This provides time to assess it and consider how it may work best.

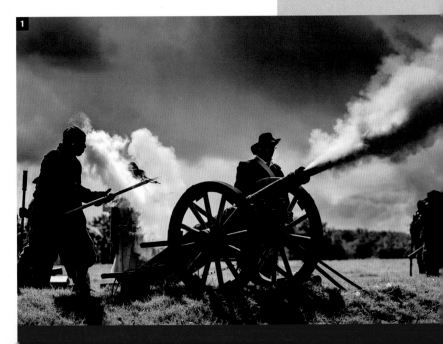

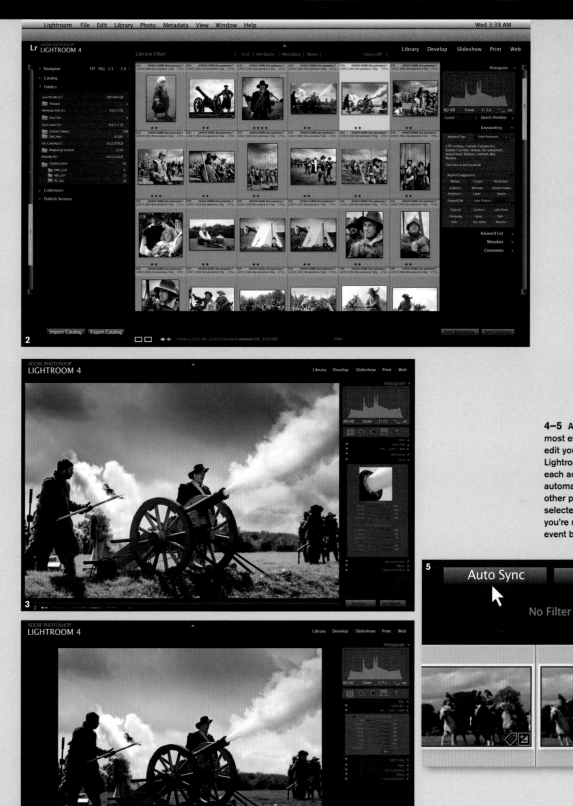

4–5 Auto Sync is the most efficient way to edit your pictures in Lightroom, and it applies each adjustment automatically to all the other pictures that are selected—great when you're making a whole event black and white.

23

The big picture

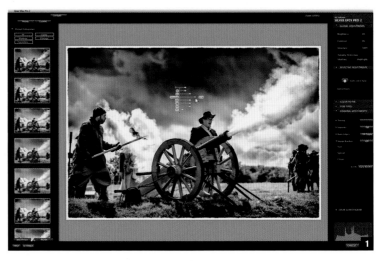

A Raw file needs to be processed or "converted" before it can be printed or shared, and there is a variety of programs known as "raw processors" that work in broadly similar but different ways. So let's step back and see the overall workflows.

When you open a Raw file directly in Photoshop, it is initially displayed in the Camera Raw window. This is Adobe's Raw processor and it works the same way in both the full professional-level Photoshop and the more consumer-oriented Photoshop Elements. You adjust the Raw file and correct its appearance in Camera Raw, and then send the converted file to the main Photoshop window. Once the picture is within Photoshop itself, you have a huge range of ways to make the picture black and white, finally saving your work as a PSD or TIF file.

In this book we're mainly seeing Adobe's Lightroom which, like Apple's Aperture, integrates Raw conversion, cataloging your pictures, and outputting them. With these programs you record or "import" Raw files in a database or "catalog" and can then correct them, prepare black-and-white versions, and then print it, show it in a slideshow, share it online, or create a book.

Nikon Capture NX, Canon DPP, and Capture One belong to another group of programs known as "pure" Raw processors. They just convert Raw files and can send them to the printer or over to Photoshop.

Silver Efex Pro is very different. It is not a Raw processor in its own right, but instead works as a

extension or plugin to Photoshop, Lightroom, or Aperture. These programs perform the Raw processing work, then create a TIFF file and send it to Silver Efex Pro. You then use its dedicated black-and-white tools before returning the picture to Photoshop, Lightroom, or Aperture for final output.

So correcting the Raw file and then making it black and white can be done entirely within Photoshop, just in Lightroom, or just in a Raw processor. Alternatively you might do the Raw processing first, then use Silver Efex Pro for the black and white. There are other workflows too, and which method you choose is one of personal preferences, budgets, friends who can help you progress, and many other factors. Isn't choice wonderful?

1 Silver Efex Pro is a dedicated black-and-white plugin for Photoshop, Lightroom, and other programs.

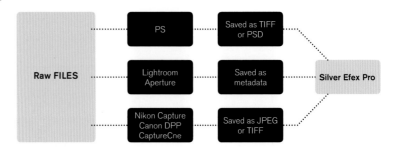

24

Use Exposure for overall appearance

1 Work downward and in pairs through Lightroom's Basic panel adjustments.

A picture's overall brightness is one of its most obvious qualities. We immediately notice if a print seems too bright or overly dark, and although we may sometimes appreciate it is being done for effect, in most cases we would find fault and not believe it reflects reality.

Adjusting an image's general brightness is one of the first things you do in post-production, and it obviously affects what happens at the extremes of the tonal range—the highlights and the shadows. If you drag a brightness or exposure slider hard to the right and brighten the picture, there's a fair chance that you would also make the highlights so bright that any detail they contain is no longer visible. At the other end of the tonal scale, you might not want to darken a picture so much that the shadows become solid masses of dense black. So you need to balance overall image brightness while staying in control of blown highlights or blocked shadows.

Lightroom's main or "Basic" adjustments panel has a number of sliders which provide control over the tonal range. These are laid out in pairs in logical order and a typical way to work would run like this:
- Set the overall brightness with the Exposure slider, and then adjust Contrast.
- Next, fine tune the brighter tones with the Highlights, and the darker regions with Shadows.
- Then use Whites to fine tune the very brightest tones, and Blacks to set the very darkest shades.
- Perform other corrections such as cleaning up dust spots, handling any high ISO noise, correcting lens distortions, and so on.
- Then go black and white.

2 You can drag the histogram to adjust the Basic panel tones.

3 No harm ever comes from hitting the Auto tone button. Here the results are a bit soft, but it's often a good starting point.

✳ Quick tips

✳ Try clicking Auto. In Lightroom you can always undo your work, so what's the worst that can happen?

✳ To reset all the Basic panel's tones, double click the Tone button.

✳ Double click any slider's text label to reset it, so double clicking the word "Exposure" sets the slider back to 0.

✳ Shift double click any slider's text label to set that slider to its Auto value.

25

Make sure there's detail in the highlights

If you've taken care to capture detail in the brightest parts of the picture, you wouldn't want to throw it away with sloppy processing. Once you are working in black and white, these brighter areas will be even more noticeable. But as you drag the exposure slider to get overall image brightness looking at its best, it can easily make highlights so bright they become burned-out or "clipped."

This clipping can often be picked up by eye, but there can be little difference on the screen between a very bright tone and an area where the detail is burned out. So Lightroom offers further assistance. So just like on the camera's rear LCD panel, keep an eye on the histogram in Develop's right-hand panel.

Apart from a spike at either end warning you of a significant problem, notice how moving the cursor around the image causes the histogram to display brightness values in percentages. So a reading of 95% indicates the area is almost, but not quite, pure white. Just remember these numbers are there to support your eyes, not replace them.

To see where the image is clipping, move your cursor over the triangle at the top right of the histogram. Like the blinking on the camera's LCD panel, any burned-out highlights are shown in a vivid red. Alternatively, hold down the J key and this clipping indication is displayed until you lift your finger from the key.

But when your attention is on dragging the Exposure slider, the quickest way to check if it's damaging the highlights is to briefly hold down the

Alt (PC) / Option (Mac) key and drag a little more. As you do this, areas of the picture that are not clipped are temporarily displayed as black, while burned-out areas are shown in colors. Blue indicates the blue channel is burned-out, cyan that you've blown green too, while white indicates that red is also clipped.

So while you're trying to set a pleasing overall brightness, just be aware of what's happening in the brightest areas of the picture. Use your eyes, and the full range of tools.

1 With bright sunlight to the left, this scene was close to being overexposed.

2 Lightroom's histogram is like a camera's—a spike on the right indicates the highlights are currently burned-out.

3 Click the triangle in the histogram or use the J key to display areas containing no detail.

4–5 Drag a slider while holding down the Alt (PC) / Option (Mac) key. Lightroom shows that dragging it to the left is reducing the area affected by clipping.

6 The overall brightness and the highlights are now set for a high-key effect which will suit this picture.

1

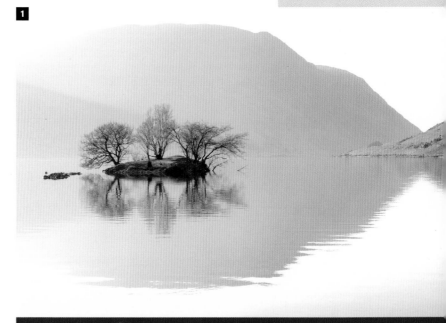

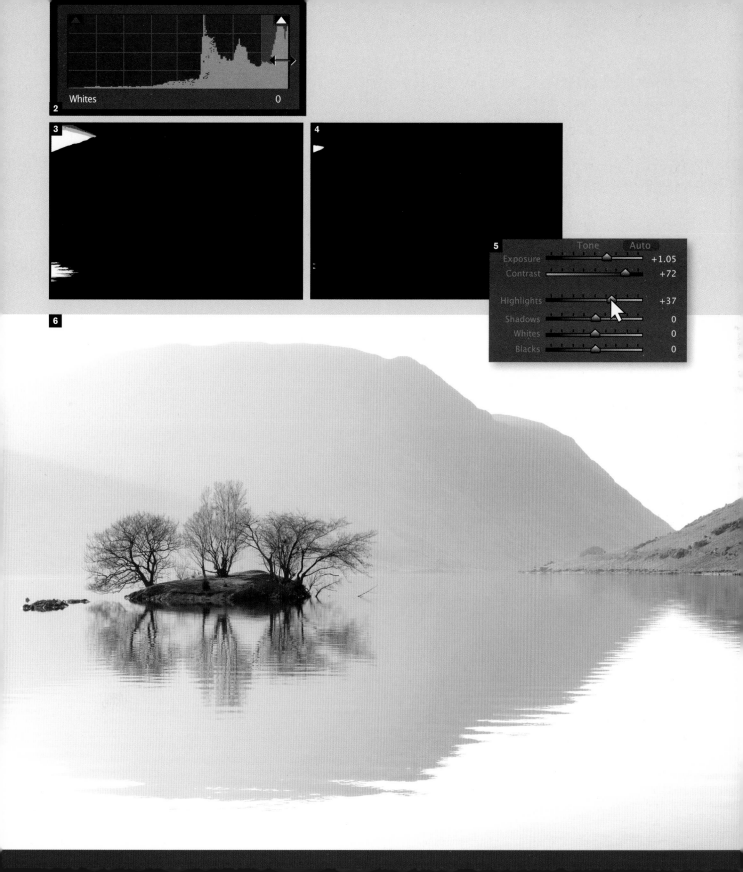

26

Less aggression

1

2

It's one thing to be aware that your picture's brightest areas are under threat, or are almost ruined. But how do you respond?

First of all, you do not need to worry. Quite the contrary—it's good that you are keeping an eye on this. It is perfectly normal that there is some tension between the appearance of the very brightest parts of the picture and its overall brightness. In fact, balancing these qualities is part of what helps bring the best out of your photo.

One approach is to back off, and not to be quite so aggressive with the overall brightness. If you drag the Exposure slider a fraction less far to the right, the picture may still look just as good as before, but with its highlights not pushed beyond their limit. The overall image may be a touch less bright, but its brightest areas remain interesting.

Again, support your eyes by making good use of the tools Lightroom offers—the histogram, clipping indicators (J), spikes, and the number readout.

The Alt (PC) / Option (Mac) key is particularly helpful with this kind of fine tuning. As you drag the Exposure slider a tiny bit back to the left, hold down Alt (PC) / Option (Mac) and the white patches will start breaking up into areas of solid color.

This is showing you that where these areas had been burned-out in all three color channels, moving Exposure to its left has limited the clipping to one or more channels. There may now be some detail visible in those parts of the picture.

So briefly release the Alt (PC) / Option (Mac) key and review the image, most of all those awkward highlight areas. That small change may be all that is needed, or you may decide to repeat the process. Press the Alt (PC) / Option (Mac) key and nudge Exposure a bit more to the left, release and evaluate. Fine tuning is often an iterative process.

1 With the clipping indicator switched on, burned-out highlights are shown in red.

2 To get the clipping view, drag Exposure back while holding the Alt (PC) / Option (Mac) key. Here there are just a few blown highlights.

	Tone	Auto
Exposure		+1.49
Contrast		+28

3 While the overall brightness of this picture looks better with more Exposure, it's wrecking the highlights.

4 Pulling back the Exposure has left the picture slightly dark, but still acceptable, and has protected the brightest areas of the picture.

27

The whites & highlights

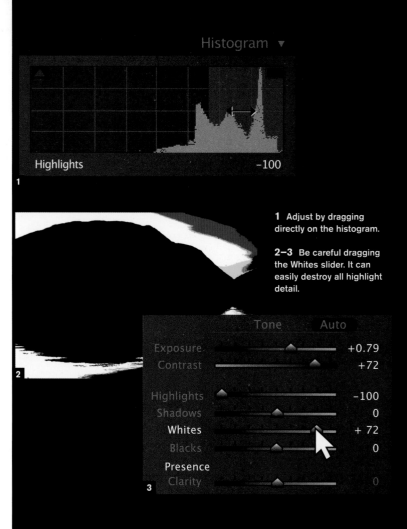

Histogram ▼

Highlights −100

1

1 Adjust by dragging directly on the histogram.

2–3 Be careful dragging the Whites slider. It can easily destroy all highlight detail.

Tone Auto

Exposure +0.79
Contrast +72

Highlights −100
Shadows 0
Whites + 72
Blacks 0
Presence
Clarity 0

2

3

Exposure is only one of the sliders which control the lighter areas of the picture—Highlights and Whites operate there too. The key is how they work together.

Exposure is the most important, and you use it to set the overall or mid-tone brightness so the picture looks right to your eyes. If that causes a little clipping, you may be able to back off Exposure and keep some detail in the brightest areas without spoiling the picture's appearance.

But it's no good protecting clipped highlights if it makes the picture look too dark, and this is where Highlights and Whites come into play. After setting Exposure and deciding the overall brightness looks right, "Highlights" are the brighter areas, but not quite the very brightest—which are called the "Whites." So these two sliders offer you separate control over these tones.

You can lift the brighter parts of the picture, but then drag Whites to a negative value and avoid clipping the highlight areas. Or you might darken the brighter image areas, but just push up the Whites—effectively increasing contrast in the highlights.

As with Exposure, you can confirm what's happening with the histogram, clipping indicators (J), spikes, the number readout, and the Alt (PC) / Option (Mac) key. Just evaluate your work with your eyes and use the numbers to confirm your intuition and artistic judgement.

One way to think of what you're doing is shaping the brighter parts of the picture. In fact, Lightroom

also lets you adjust the picture by dragging on the histogram itself, and as you drag part of the histogram it displays a label indicating which slider it is moving.

Don't try to remove all clipping. It's the large, featureless patches of white that are most likely to look wrong in the final picture. But we are not so troubled by pure white details, and it's too easy to remove all life or sparkle from a picture by leaving no whites at all. This is where the Alt (PC) / Option (Mac) key is so handy—making it easy to set the sliders and keep just a few specks clipped highlights.

Tone		Auto
Exposure		+0.79
Contrast		+72
Highlights		+100
Shadows		0
Whites		−54
Blacks		0

4

5

4 Here the Highlights in general are brighter, but the Whites have been pulled back.

5 The brighter highlights mean the picture is a touch more high key, but reducing the Whites means the very brightest areas don't burn out.

6 The overall brightness and the highlights now look right.

6

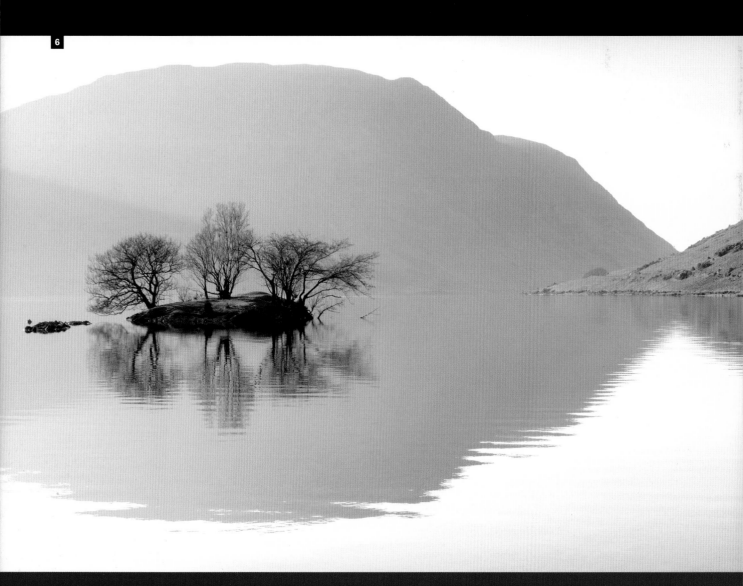

28

The shadows & blacks

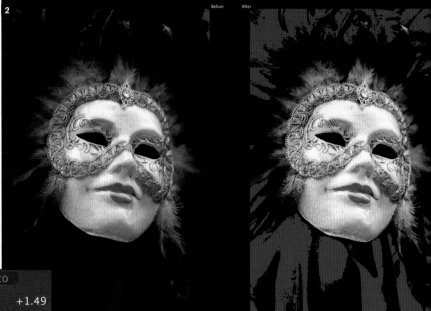

1–2 The clipping indicator shows large areas of this picture will print as solid black.

Of course, changing the picture's brightness with Exposure doesn't affect only the highlights—it also affects the darker tones. We can often think in similar terms too, and blocks of pure black can be just as harmful to a photograph as empty white patches. Equally, just as the presence of some pure white provides life or sparkle to a black-and-white image, so some pure blacks can give it "crunch" and "anchor" its range of tones.

One slight difference is that we are accustomed to detail becoming indistinguishable in the darkness, so impenetrable shadow tones are not quite so unrealistic or unexpected in a photograph. We just don't want to lose interesting details because of lazy post-production work. So just like the highlights, you try your best to get the darker tones looking right before you switch to black and white.

Once Exposure has the image's overall brightness looking right, use "Shadows" for the generally darker areas. If you drag the slider hard to the left it can darken the shadows so much that they

become black, but it is much less brutal than "Blacks" which controls the very darkest tones. So once you have used Shadows to adjust the darker areas of the picture, then use Blacks with care to provide that crunch black point that anchors the tones.

As with the highlights, you can manipulate the darker tones directly on the histogram, dragging it to the left to darken or to the right to lighten them. You also have all the other clipping indicators, and again the Alt (PC) / Option (Mac) key is very handy indeed.

Drag Shadows or Blacks while holding down Alt (PC) / Option (Mac) and the picture is displayed in clipping mode. White now indicates there is no clipping in any channel, while black indicates a problem across all three channels and shows you how much of the picture is blocked up.

Set Shadows so the darker tones look right, then drag Blacks while holding down Alt (PC) / Option (Mac) until just a few specks of clipping remain here and there.

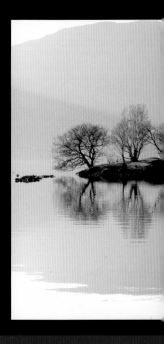

Highlights	−32
Shadows	−21
Whites	+21
Blacks	−23
Presence	

5 The picture now has deep shadows, which suit the subject, but they still contain detail.

3–4 To anchor the picture with a hint of black, drag Shadows or Blacks, holding down Alt (PC) / Option (Mac) while dragging sliders.

✳ Tip

The histogram will often end up just touching the left-hand side.

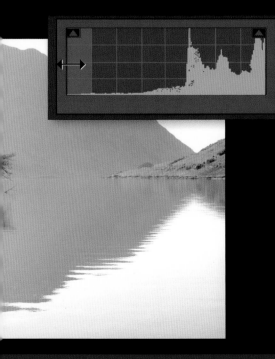

29

Other corrections

1

Spot Edit:

2　Size

You have set the image's overall brightness and contrast, fine tuned its brighter and darker tones, and there is a good tonal range with touches of black at one end and white detail at the other. It's looking fine—but it's in color. Surely now it must be high time to make the picture black and white?

Well, not quite. You've not quite finished correcting the basic picture, and there are a few other common defects which will need fixing at some point. It's better use of your time to get these corrections done before getting on with the creative B&W fun, and this also helps reduce the risk that these problems may slip your mind. You can always fine tune corrections after going black and white, but if you're working in an orderly manner, you'll get the dirty jobs done first.

Sensor dust spots
With every DSLR, it's very likely that before too long you will find that some dust has made its way onto the sensor and shows up on your pictures. You can take lots of care changing lenses, run the camera's dust removal routine, and regularly clean the sensor with a specialist brush or swab, but dust remains a fact of life for digital photographers.

At smaller apertures these dust specks will be visible as small dots—the smaller aperture helps focus the dust—and these will be most obvious in clear blue skies or other areas of even tone.

Not long ago cleaning away these spots used to be a task for Photoshop's cloning stamp too,

but now all modern Raw processors have a dust-removal feature.

In Lightroom, move to the top left of the picture and zoom in to 1:1 magnification. Then activate the dust-removal tool and work around the screen dabbing any spots. They vary in size, so use the "[" and "]" keys to reduce and increase the spotting tool's size, respectively. Once the current screen is clean, use the Page Down key and repeat the procedure. When you reach the bottom of the image, using Page Down again will move the window back to the picture's top and to the right. So you can systematically clean the entire frame.

One small blessing is that dust spots are often in identical places on a series of frames. So use the Sync button to copy your healing work from one picture to others.

1–2 With smaller apertures and clear skies, dust spots are an occupational hazard. Lightroom's dust-removal tool allows you to control the size of the area that will be healed.

30

Sharpening

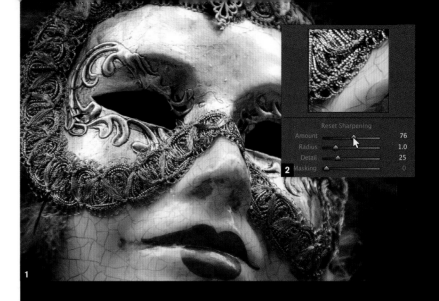

Sharpening at an early stage of the workflow is known as "capture sharpening," and it is a small dose of sharpening to counter the softening effect of a digital capture that consists of pixels.

The default value is often enough, but Lightroom also provides two presets "Sharpen—Faces" and "Sharpen—Scenic" which are even better starting points.

You then adjust the degree of sharpening with the Amount, and also with Radius which controls the area over which the sharpening halos are spread. Higher Radius makes fine details stand out, sometimes too much, but works well on softer features like skin.

Higher levels of sharpening may suit some parts of a picture while producing unrealistic side effects elsewhere, and this is when you use the Detail and Masking sliders to target the sharpening. Lower Detail values counter the halos, while the Masking slider is wonderful for protecting smoother-toned areas which do not require sharpening. You can hold down the Alt (PC) / Option (Mac) key while dragging these sliders and Lightroom provides a preview of the effect. With the Detail slider, it displays the halo, while Masking shows protected areas in black and uses white for the edges which will be sharpened.

1–2 Amount sets the strength of the sharpening and Radius the area over which its halo spreads.

3–4 Hold down the Alt (PC) / Option (Mac) key while dragging Detail to target the sharpening.

5–6 Hold down the Alt (PC) / Option (Mac) key while dragging Masking. The white areas—edges—will be sharpened while the areas of smooth tone are shown in black and will be left untouched.

31

Noise reduction

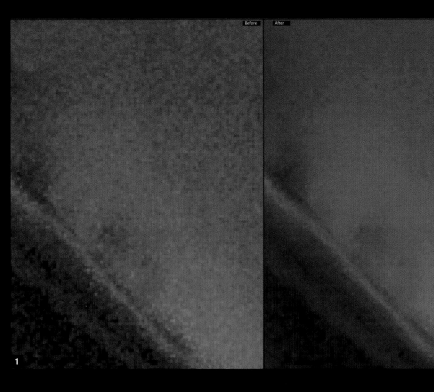

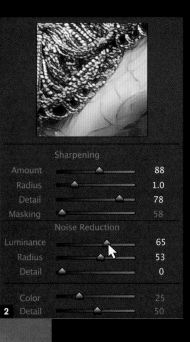

1–2 Zoom in to 1:1 or more to deal with high-ISO noise, but remember you are blurring the image.

When a picture is taken with a higher ISO, it becomes "noisy"—the sensor's circuitry interferes with the light reading. The higher the ISO, the more this noise is visible as a sort of grainy effect.

All Raw converters include noise reduction features. Zoom in to 1:1 so you can really see the noise, and then drag the Luminance slider in Lightroom's Detail panel. This is a blurring effect, and the key is to use only enough Luminance smoothing to hide the noise. Too much noise reduction removes detail and can produce plastic-looking tones.

The more Luminance smoothing you apply, the softer the image may become. So try to correct noise at the same time as the capture sharpening. It's often an iterative process.

32

Correcting lens distortion

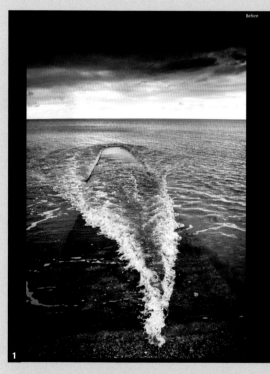

1–2 Correcting lens distortions can be done before or after converting the image to black and white.

Lens problems are slightly different from other image defects that need correction. Not all Raw processors include lens-correction features, and a lot of computer power is needed. So lens correction has generally been handled by the great workhorse, Photoshop, or by specialist tools like DxO. But Lightroom and CaptureOne now both offer lens correction which automatically recognizes modern lenses. A lot depends on your lens—if it shows obvious optical flaws, you may want to apply lens correction more often, and perhaps before making the picture black and white. Otherwise, lens corrections often slow down the computer, and there's no point applying lens correction to every picture. So correct problem pictures only, and consider doing it later when you've finished other work.

33

Crop, rotate, & mirror

1 Lightroom's crop tool offers presets for common aspect ratios.

Cropping is a task that lies on the border between correcting a picture and applying creativity. We may be forced to correct our poor composition, and cropping often goes with straightening a wonky horizon, but it is not important whether you crop before converting the picture to black and white or later. What matters more is that you regard it as a powerful tool in its own right.

Cropping is done in Lightroom's Develop workspace and has the keyboard shortcut R. The picture is slightly dimmed and the cropping rectangle is displayed as an overlay.

Notice too that the overlay has a grid which acts as a compositional guide. It defaults to the rule-of-thirds but if you press the O key a few times the grid will cycle through other guides like the golden spiral.

You can then drag the rectangle from any side, or drag any of the corners. So you might crop so the horizon is off-center, along one of the thirds, or to make a leading line run directly in from the corner rather than from just along the side. Crop tighter around the subject to emphasize it, or alternatively crop to eliminate distracting details near the picture's edge.

Then just press the Enter key on the keyboard or the Close button to apply the crop. Or use the Esc key or the Reset button to cancel it.

If you want to rotate the image a little, move the cursor outside the crop rectangle so the cursor changes into a pair of arrows. You can then drag the image around. If that seems awkward or imprecise, a helpful technique is to hold down the Ctrl (PC) / Cmd (Mac) key and drag a line on the picture. Lightroom then rotates the picture and snaps it this line. It's ideal for straightening horizons or vertical lines.

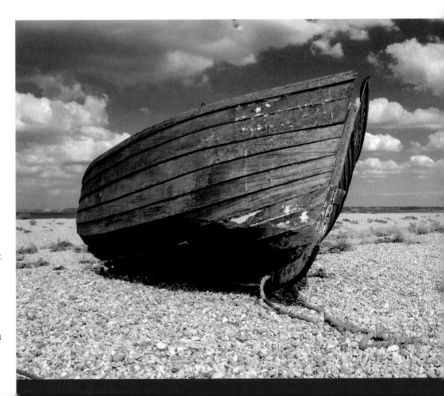

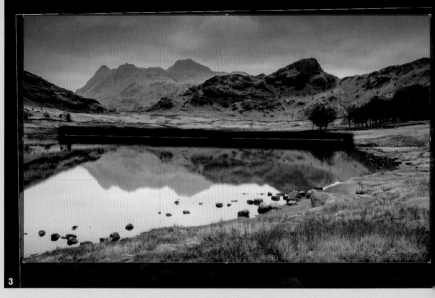

2 Don't hesitate to crop
distracting details out of
a picture.

3 Cropping and rotating are often done together. Hold
down the Ctrl (PC) / Cmd (Mac) key and draw a line to tell
Lightroom how to straighten the image.

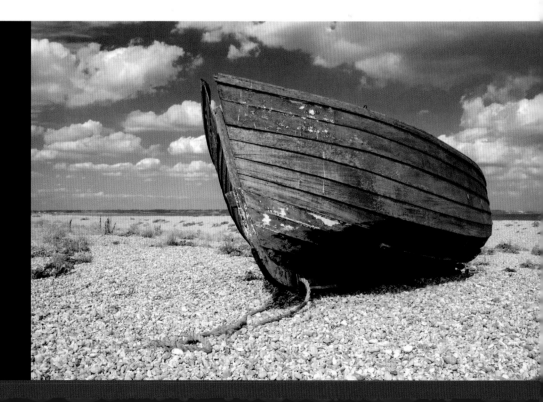

✳ Tip

One trick that is often
overlooked is that some
pictures work better when
they are flipped so they
"read" from left to right. In
Lightroom this is done
with Photo > Flip
Horizontal. Just be careful
that there's no text or
anything in the picture
that gives the game away!

34

Virtual copies

Ask yourself a quick question. Do you want to make the picture black and white, or would you really prefer to have both B&W and color versions of it?

If you simply want B&W, you don't have to do anything special—just move straight on. But if you do want to keep color version as well, you'll be glad to know that programs like Lightroom and Aperture were designed to make your choice painless.

These programs record your work as relatively tiny amounts of data, "metadata," in their database or cache. This distinguishes them from Photoshop, which saves your work as a TIF or a PSD file which can easily require ten times as much disk space as the original Raw file. These Raw processors require little disk space to save alternative versions of your files, and Lightroom and Aperture are both designed to manage all these extra pictures too.

So, you select the picture, right click, and choose Create Virtual Copy—or "versions" in Aperture and "variants" in CaptureOne.

There is still only one Raw file, but the virtual copy is a second thumbnail that exists in Lightroom's Library. One copy will be the B&W and the other will be left in color. It doesn't matter much which is the copy and which represents the original or "master," but you can recognize the copy by a little rolled-up corner and a badge such as "1" or "2." You can produce as many virtual copies as you wish—a black and white, a sepia, a blue-toned, and so on.

✳ Tip

Virtual copies are perfect when you need to do a quick alternative treatment of an entire shoot or event such as a wedding. The best way is to select all the color pictures in Lightroom's Grid view (G), and then create a new Collection. Give it a name, and tick the Make New Virtual Copies check box. Hundreds of virtual copies are created in a flash, and they are grouped together in the Collection so they're easy to find.

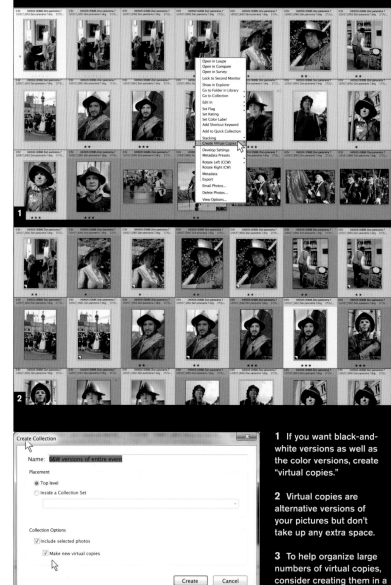

1 If you want black-and-white versions as well as the color versions, create "virtual copies."

2 Virtual copies are alternative versions of your pictures but don't take up any extra space.

3 To help organize large numbers of virtual copies, consider creating them in a new Collection.

35

Not all methods are equal

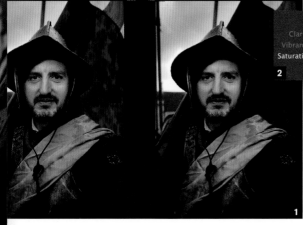

1–2 Don't be tempted to reduce Saturation to -100%.

3–4 The Lab method involves converting the image to Lab mode and throwing away one of the channels. It produces a pleasing black and white, but we have no creative control.

5 More modern methods allow you to choose from alternative black-and-white treatments. Notice how the skin tones differ in color and how the sash can be subdued or emphasized.

For over 20 years, techniques for making pictures black and white have been accumulating. Methods from Photoshop's distant past were great in their day and can still do the job, so they jostle for attention with newer, better ways to work. For the beginner, it's far from obvious which techniques are up-to-date, and which are best forgotten.

Don't be tempted by the Saturation slider. Dragging it to -100 will certainly remove all color from a picture, but that is all you are doing. You can't apply your judgement to the black-and-white conversion—for example, choosing to make blues a darker shade of gray, greens a lighter shade, and reds lighter still. Using the Saturation adjustment means you're sacrificing your best chance to produce the best possible black-and-white version of your picture.

Many of Photoshop's older ways to make pictures black and white should be avoided for the same reason. Without attempting to list them all, it's the sacrifice of your creative opportunity that makes

methods like the Image > Mode > Grayscale command a poor choice. Another technique based on Image > Mode > Lab Color can still produce pleasing tones, but you have no creative control. A second problem is that these methods are "destructive." What that means is that after you save the picture and close Photoshop, you can't open the file later and fine tune your black-and-white conversion.

But the main point is to be wary of a method of converting to black and white doesn't allow you to manipulate how color channels render into grayscale tones. It's probably best avoided, and that's so much easier once you see what you can do with the better, more modern techniques.

37

Use presets, but never be ruled by them

1 Before you apply a preset, review the results in the Navigator panel.

In the same way that most cameras provide a range of built-in picture styles, most image-editing programs offer their own presets or styles. These can certainly be a quick and convenient way to turn your pictures black and white and apply a variety of other popular looks, but they can also make you lazy. You need to learn to use them, but not rely on them.

Applying presets couldn't be easier. In Lightroom, when you register or "import" new pictures, there is even an option to apply a Develop Preset automatically. But it's much easier to judge a preset's effect once the pictures are already imported and you are working on them in Lightroom's Develop workspace. There are a dozen different black-and-white presets—you simply move the cursor over each one in turn and Lightroom displays a preview of its effect in the Navigator window at the top left. Click a preset, and it's applied.

As well as the presets built into the software, lots are available online. Many are shared by enthusiasts and these presets are usually every bit the equal of any that you have to pay for, or that make big claims. Some presets say they emulate specific black-and-white film stock, even if real film grain and other characteristics can be affected by a number of factors. So it's best to wait until you are no longer a beginner and have the experience to decide if these are good value for money. It may be a cliché, but the best things in life are often free!

Whenever you apply a preset or style, make sure you watch precisely how it changes your picture's

appearance. It may have been designed to do more than simply setting B&W panel sliders—for instance, it may also change sliders in the Basic panel. This may then affect your picture's overall brightness, shadows, or highlights.

The other reason for watching carefully is so you can identify which sliders have been updated. You can learn from what the preset has done, and go on fine tune its effect yourself.

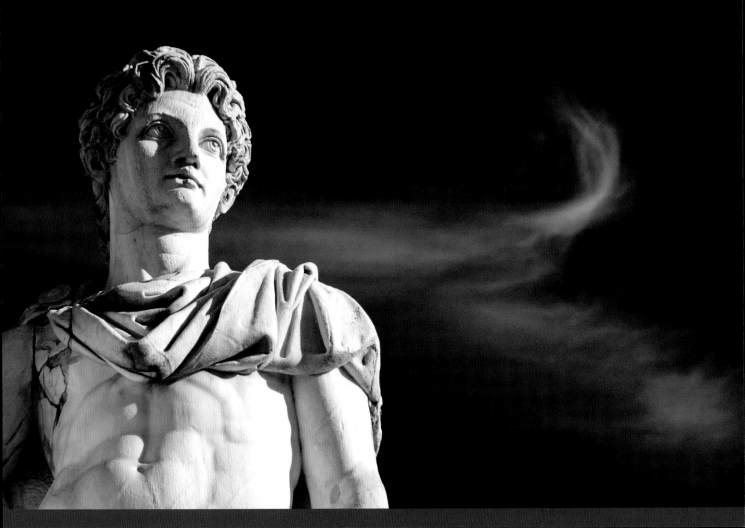

▼ Presets

⊳ Graduated filters
⊳ John's Black and White
▼ Lightroom B&W ~~Filter~~
　　　　New Folder
▦ Blue Filter
▦ Blue Hi–Co　　Import...
▦ Green Filter
▦ Infrared
▦ Orange Filter
▦ Red Filter
▦ Red Hi–Contrast Filter
▦ Yellow Filter
⊳ Lightroom B&W Presets
⊳ Lightroom B&W Toned Presets
⊳ Lightroom Color Presets
⊳ Lightroom Effect Presets
⊳ Lightroom General Presets
⊳ Lightroom Video Presets
⊳ Nikon styles – Camera Calibration
⊳ User Presets

2

3

2 Lots of presets are available online. Bring them into Lightroom by right-clicking in the Presets panel and choosing Import.

3 In many cases the preset can give the picture a fine black-and-white style without any further work (or skill).

38

Evaluation

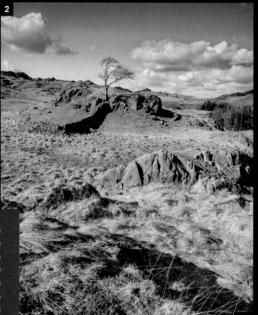

1 Give Auto a try, but rely on your own judgement.

2 The F key makes Lightroom fill the monitor, hiding your desktop and other programs, and you can also hide Lightroom's side panels.

A quick way to make a picture black and white in Lightroom is to just hit the keyboard shortcut V, or click the B&W panel down Develop's right-hand side. Below the B&W panel's sliders is an Auto button. It is always worth trying a "lucky dip."

It does no harm to hit Auto. Don't imagine that this Auto button hides any significant wisdom about the aesthetics of black and white. It's great if its results are attractive, and you have saved yourself a little time. And what's the worst that can happen? So if you don't appreciate Auto's results don't hesitate to undo it—Ctrl Z (PC) / Cmd Z (Mac).

It doesn't matter whether you use Auto, or decide you can always do better. What's important is that you evaluate the initial black-and-white appearance of your picture, and don't settle for "auto" or "default."

Examining this picture, I'd have to describe Auto black and white as rather bland. The sky and the landscape have been turned into roughly the same shade of gray, and so as a viewer I am left unsure which I should be paying attention to. The sky is also rather washed out, meaning the clouds aren't particularly noticeable, and the grass seems darker

than in the original scene and not very distinct from the dry stone wall around the tree.

It doesn't matter whether you use Auto, or decide you can always do better. What's important is that you evaluate the initial black-and-white appearance of your picture, and don't settle for "auto" or "default."

Examining this picture, I'd have to describe Auto black and white as rather bland. The sky and the landscape have been turned into roughly the same shade of gray and so as a viewer I am left unsure which I should be paying attention to. The sky is also rather washed out, meaning the clouds aren't particularly noticeable, and the grasses seem darker than in the original scene and not very distinct from the dry stone wall around the tree. Notice how I'm thinking here about the contents of the picture, about their tones are subdued or bright, about the differences between elements of the composition. While Auto isn't bad, what it has failed to do is convey what I think the picture needs to express. If you hadn't seen the color original, you wouldn't sense from this undramatic black and white that it was actually a gorgeously-bright afternoon.

5 To focus on one specific task, activate "Solo Mode" by right-clicking a panel's header, and Lightroom will keep open only the panel where you are working— less distraction and less scrolling up and down.

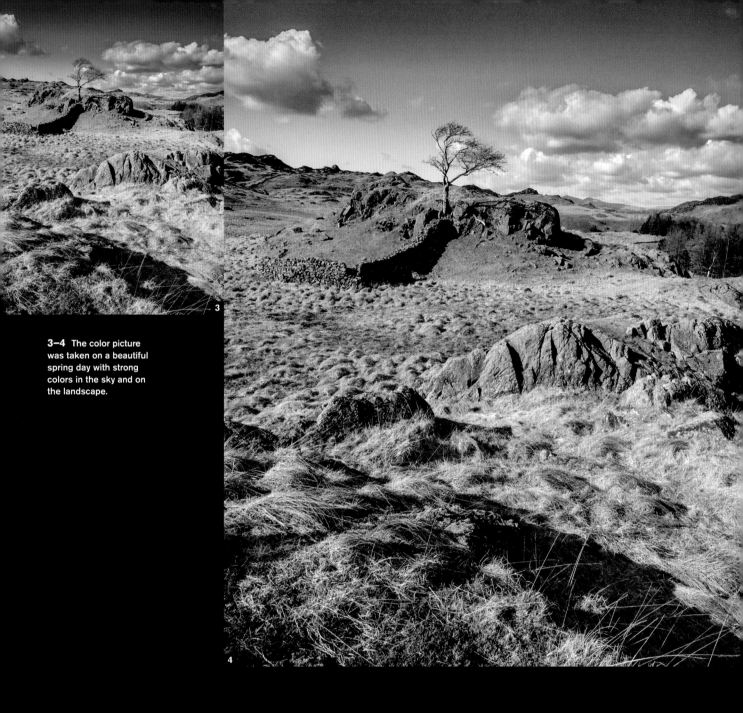

3–4 The color picture was taken on a beautiful spring day with strong colors in the sky and on the landscape.

3

4

39

Learn to use on-image tools

The traditional way to work with sliders is to drag them to the left and right. So if you drag the Blue slider to the right you are telling Lightroom to render blues in a lighter shade of gray. Drag it to the left and you're instructing it render them darker. That's fine when one part of the image is obviously of one color. You know the sky consists of blues, so you know which slider to drag.

But with the rest of this picture it's a bit more trial and error. Can we control the grayscale tone of the grasses by dragging green, yellow, or even orange? Apart from the guesswork, it's a bit tedious to be compelled to drag three sliders and, as well as a lot of work with the mouse or tablet, your eyes have to keep jumping back and forth between the picture and the sliders.

That's why Adobe added a "targeted adjustment tool" or "on-image tool." In Lightroom, you click the little circle at the top left of the B&W panel, while in Photoshop there's a hand with a couple of arrows. The first thing you notice is that the cursor gets a

couple of arrows. To deactivate it, click again or press the Esc key. The power of the on-image tool is that it lets you adjust your black-and-white conversion by stroking the image. It samples the colors in the area where you stroke, and drags the B&W panel sliders for you. Stroke upward and it renders those colors as lighter grays; downward and the sampled colors are rendered darker.

This is beautiful because you're working directly on the picture, and all the time you're stroking it you're observing how its appearance changes in real time. You no longer need to guess if dried grasses may contain yellows or oranges— the on-image tool does that for you—and you're not being distracted by continually going over to the sliders. It's a really interactive way to fine tune your black-and-white conversion.

1 Drag the B&W panel sliders to control how colors are rendered as shades of gray.

2 The "targeted adjustment tool" or "on image tool" is the best way to control the black-and-white conversion.

3 Notice how the cursor changes when you're working with the "targeted adjustment tool" or "on-image tool."

Stroke downwards to darken range of colors

Drag upwards to lighten

4–5 Stroke upward to brighten how colors appear in black and white, downward to darken their appearance.

4

5

40

Improve your work by checking the Before/After view

When a black-and-white conversion begins to look good, it can be hard to see how it might be better. With experience often comes a sense that you can squeeze more out of a picture, but there's always a point when you don't know for certain. Would changing the B&W mix improve a picture, or would it possibly ruin what you've already done? How would you be sure?

One approach is to save more than one version of your work. In Photoshop you can duplicate the picture and compare the versions, while Lightroom, Aperture, and CaptureOne offer "virtual copies," "versions," or "variants."

But a much more elegant approach is Lightroom's Before / After view which splits the screen in two. This split-screen view is extremely helpful when you are fine tuning and it is specifically designed to provide a comparison or a benchmark to help you evaluate your progress. There are some obvious ways to use it, but a few ways surprise people and are really good to know.

The keyboard shortcut for Before / After is Y and it usually splits Develop's window vertically. The After side is always the picture as it is right now, but you have more control over the Before side than you may imagine.

Initially Before shows the color version, which makes less sense the more you fine tune your black and white. So click the Copy After's Settings to Before button. You can create this new benchmark whenever you need.

1

There's another way to change the Before view—you can just drag a step from Lightroom's History panel and drop it on the Before side. This lets you compare further adjustments against earlier versions of the picture.

So in this picture, darkening the sky subdues the upper regions of the composition, capping the scene and nudging attention back down toward the landscape.

Stroking upward with the on-image tool lightens the landscape. The thought process here is that making the grass lighter tones will separate it from the stone wall and make it more obvious. It was unusually dry and brighter grasses make the picture convey the brightness of the day. With Before / After, it's easy to see—and then optimize—the improvement.

1 Whenever you want, copy the current or "After" state of the picture to "Before" and make it your benchmark.

2 When you are working on an image, Lightroom's Before / After view is a great way to gauge your progress.

3 You can compare your work to any previous stage in the editing process—just drag a history step into the Before window.

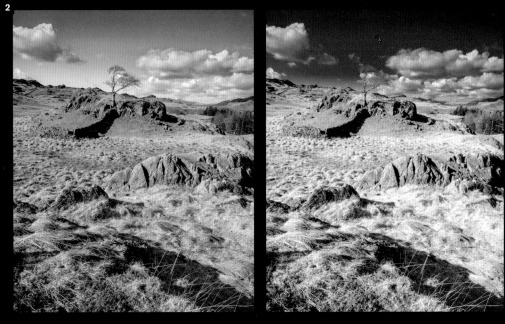

41

Tonal separation

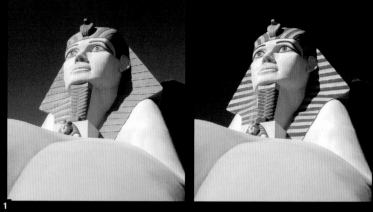

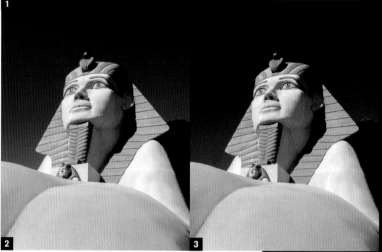

1

2

3

It's important to pay attention to tonal separation and not worry too much about the picture's overall brightness and contrast. If the black-and-white mix does make the picture duller, that's no problem—we can bump them up again. But if it renders differently-colored areas of our picture as identical shades of gray, no amount of playing around with the contrast is going to make them look different again.

It's such a key point that it's best to take an example—the Las Vegas sphinx with its yellow and blue striped headdress—and compare two treatments in Lightroom's Before/After window.

Before shows a default or lazy conversion to black and white, and notice how a couple of things have gone wrong. Most obviously, the overall image contrast looks soft. But intuitively we would return to the Basic panel and bump up the contrast.

Much more troublesome is that we've not exploited the colors that were in the original picture. See how the headdress's stripes have become similar shades of gray, and a viewer who had never seen the original scene would have little sense that the stripes' colors alternated. Sometimes this loss of tonal separation may be what we do want to achieve, while in other cases we may be unhappy at our failing to convey interesting information about the subject. You just have to watch what's happening to the picture, and make your own judgement. In this case, the lazy conversion has also sacrificed an important graphic quality—the way the yellow stripes formed powerful diagonal lines.

The After version shows what can be achieved if you do think about tonal separation and make it the first step in your black-and-white conversion.

The yellows and the blues are now distinct shades of gray. The viewer readily sees the stripes were different colors, and we've retained the original composition's contrast between the sculpture's curves and stripes.

So as you drag the B&W sliders or its on-image tool, watch how the conversion affects the contrast between differently-colored areas of the picture. Tonal separation always comes first—it's the great opportunity to stamp your creative judgement on the black-and-white conversion.

1 It's very informative to split the screen into Before/After view and see how much you can improve from the default black-and-white conversion.

2 An image as colorful as this often works equally well in black and white.

3 The default black-and-white conversion looks fine overall, but the stripes all look the same.

4 A more careful black-and-white conversion has separated yellows and blues into distinct shades of gray.

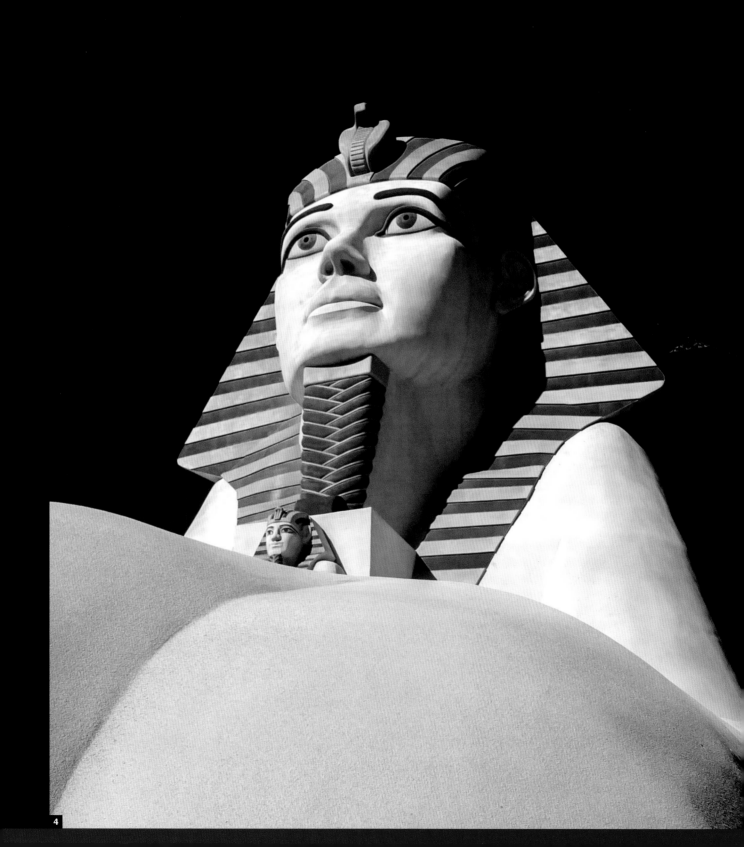

42

Tonal separation & skin tones

1 Dragging the targeted adjustment tool upward over the skin tones produces more pleasant skin tones.

When people are the subject of your picture, there's a key question that you should ask yourself when you make the picture black and white: Do you want to hide differences in skin tone and make it seem smoother? Alternatively, do you want to keep natural variations in skin tones, and perhaps make them more obvious?

Your choice of subject may immediately dictate the answer. A woman may not thank you for a photo showing skin imperfections or her wrinkles, so you may want to set the black-and-white conversion so you don't separate skin tones.

This generally means brightening the shades of gray used for the skin tones. While you may reach for the red slider, skin tones include a range of colors. So the easiest, most intuitive way to adjust skin tones' grayscale appearance is with the targeted adjustment or on-image tool. Activate it by clicking the little circle in B&W panel and move the cursor over the face. Then gently stroke the picture in an upward direction. Lightroom will sample the skin tones and move the sliders for you. Differences can be subtle, so make sure you activate the Before / After view as you perform this fine tuning.

On the other hand, the same conversion recipe may make a man's facial tones look gentle and boyish. So you have to consider what you want to say about the subject—make him look youthful, or bring out a more masculine character? In this case, dragging downward with the targeted adjustment or on-image tool will make Lightroom darken skin

tones and make details more obvious.

Always notice that changing the B&W mix doesn't just affect the skin tones—it affects other parts of the image where there are similar colors. While this can sometimes upset the picture's overall brightness and contrast, you can always go back to the Basic panel and adjust these.

2 The black-and-white conversion allows us to manipulate the mood of a portrait.

Reset Black & White Mix	
Red	−60
Orange	−42
Yellow	−60
Green	0
Aqua	+38
Blue	+63
Purple	+17
Magenta	+10
	Auto

3–4 More detail can be revealed in skin tones by stroking downward on the face with the targeted adjustment tool. With this picture, it brings out the tension in the man's expression.

5–6 Soften skin tones by dragging the targeted adjustment tool upward over the face.

Reset Black & White Mix	
Red	+50
Orange	+38
Yellow	+36
Green	−5
Aqua	+25
Blue	0
Purple	−30
Magenta	−40
	Auto

43

Tonal separation & landscapes

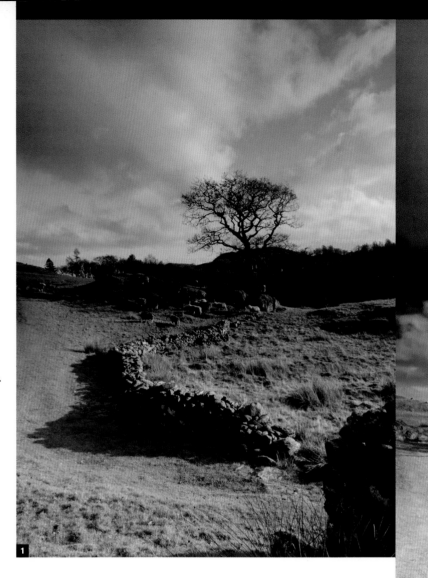

How to give a landscape photo the "Ansel Adams' look" must be one of the most popular requests from photographers who appreciate black and white. Fortunately, it's not so narrow a style and there's plenty we can learn from the great American landscape photographer. After all, Adams literally wrote the book on tonal separation.

The key ingredient of the famed "Ansel Adams' look" must be the sky. Puffy white clouds stand out clearly against blues which are rendered as nearly-black shades of gray. Adams was using lens filters to achieve this tonal difference, but the underlying concept was the same.

As usual, you can drag the sliders or activate the targeted adjustment tool. Click the little circle in B&W panel and the cursor will grow a pair of arrows, and you then use it to stroke the picture. Stroke downward on the blue of the sky and Lightroom will drag the blue slider to its left, possibly others sliders as well if it detects those colors in the area. A little at a time works best, and again use of the Before / After view to confirm you're on the right track.

Darkening the sky usually does a couple of things for the landscape picture. By emphasizing the clouds, you are adding interest and making the most of what is often a significant proportion of the frame. Secondly, because the sky occupies the top of the picture, its subdued appearance helps direct the viewer's attention downward onto the landscape. Darkening a sky is about much more than imitating Ansel Adams' style.

The rest of the landscape picture would often include grass, trees, and other foliage. It is probably natural to reach for the green slider to brighten or darken how these areas look in black and white, but greenery often contains yellows and other colors. So again use the targeted adjustment or on-image tool and stroke the picture to darken or lighten the B&W tones. It's quicker, and soon becomes intuitive.

1 Blues in the sky can be used to manipulate the black-and-white conversion.

2

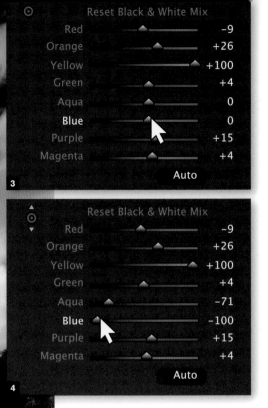

Reset Black & White Mix		
Red		−9
Orange		+26
Yellow		+100
Green		+4
Aqua		0
Blue		0
Purple		+15
Magenta		+4
	Auto	

3

Reset Black & White Mix		
Red		−9
Orange		+26
Yellow		+100
Green		+4
Aqua		−71
Blue		−100
Purple		+15
Magenta		+4
	Auto	

4

2–4 By adjusting the black-and-white mix, the sky is strengthened and cloud detail is emphasized.

5 After's stronger sky "caps" the scene and directs attention down onto the landscape. On the Before side, there is little contrast in the sky and it looks far too similar to the landscape.

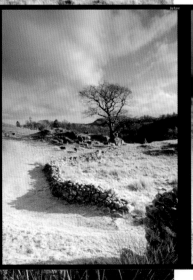
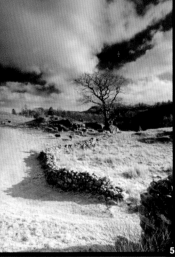

5

44

Dodge to add emphasis

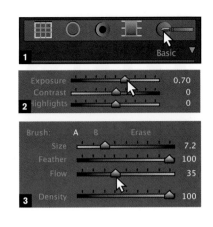

1 Activate the Adjustment Brush by clicking this button.

2 Brighten an area by dragging Exposure to the right.

3 Gently does it—set Feather to 100 and a low Flow value.

Once you've corrected the picture and you have fine tuned the black-and-white conversion, you are usually well on your way to the finished photo. Overall, it should now be looking pretty good and should be is beginning to be your interpretation of the subject. It's time to turn your attention to its key elements and to ask how they might be made to punch their weight?

"Dodging and burning" is a technique that has formed part of black and white since photography's 19th century beginnings, and the underlying idea hasn't really changed. To make areas of the picture more obvious, you lighten or "dodge" them. "Burning" or darkening other features makes them less distracting.

Dodging is performed in Lightroom with the Adjustment Brush which you activate by the keyboard shortcut K (and which also closes the tool when you're finished). The cursor changes into a pair of concentric circles, the brush's full effect being in the inner one. The outer circle shows where the effect tails off, and you set this "feathering" using the Feather slider.

Each time you activate the Adjustment Brush, immediately review the sliders. If you want to lift all the tones, set a positive Exposure value, while Highlights or Shadows would restrict your dodging to the corresponding tonal ranges. For now, make sure other sliders are all set at zero.

Also review the brush's Size slider, set Feather to 100 so your work will blend in, and Flow should be

50 or lower, for the same reason. Now just brush the area of the picture you want to brighten and watch as the effect builds up.

You can dodge other areas, and set different slider values for each application of the brush. Press New, review the sliders, and stroke away.

You can change the level of dodging afterward by moving the sliders. Notice how each adjustment is pinned to the picture by a little circle, with the one that's currently active containing a black dot. Click any circle to re-activate that adjustment and fine tune the sliders, or hit the Delete key to remove the adjustment altogether.

4–5 Brightening the face draws attention to the subject.

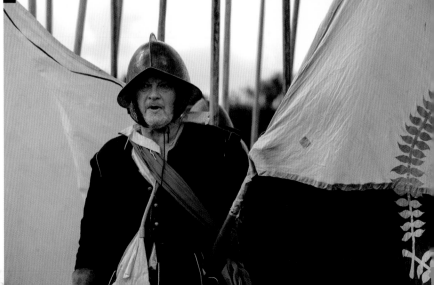

Burn in to subdue parts of the frame

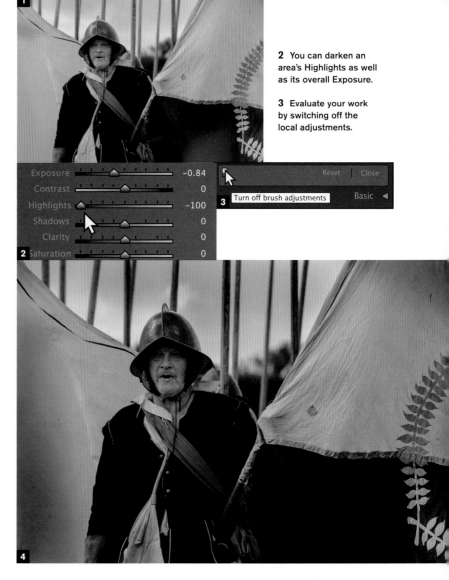

1 Have a mental plan of what you want to achieve. Here the red overlay shows the areas I've darkened.

2 You can darken an area's Highlights as well as its overall Exposure.

3 Evaluate your work by switching off the local adjustments.

4 Burning in brighter areas around the frame's edges has directed attention down and into the frame.

Just as you "dodge" or lighten some parts of the picture so they are more obvious, make other features less noticeable in black and white by "burning in" or darkening them. Use the Adjustment Brush in exactly the same way, just with negative values for the sliders.

Either use the keyboard shortcut K to activate the Adjustment Brush, or click the tool at the top of Develop's right-hand side. Again, always run your eye down the sliders and ensure they are set how you want, and review the Size, Feather, and Flow.

There are no fixed rules, but use Exposure, Highlights, or Shadows flexibly. Exposure is often good, but you may choose Highlights when you only want to darken the brighter tones in the problem area, while Shadows is for darkening the area while protecting its highlights.

Stroke the image areas you want to darken, building up the adjustment little by little, and as with brightening areas of the picture, don't try to make a single local adjustment pin do all the work. Click New and add a separate brush circle—add as you need.

There are a few handy ways to evaluate your work. As so often in Lightroom, use Before / After (shortcut Y) and remember the button Copy After's Settings to Before which sets the current state of the picture as your benchmark. Even if you are not in the Before / After's split screen view, you can always hold down the \ key to temporarily display the Before state.

A similar quick technique is to briefly switch off the Adjustment Brush tool. Just click the small light switch in its panel, and afterward flick it back on again.

Most of the time you can—and should—trust your eyes to evaluate the local adjustment's impact on the picture. When the difference may be unclear, another really helpful shortcut is O for Overlay. This is available when a single local adjustment is active—identified with a black dot—and displays a mask over the area of the picture affected by the adjustment. Press O again to hide the mask.

46

Revise your dodge & burn technique

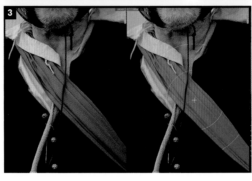

A great thing about working in a program like Lightroom is that you don't need to be discouraged if you change your mind about the dodging and burning. We all do that! Upon reflection your local adjustment work may look too strong or look artificial, or it might be too subtle and fail to change the emphasis of your composition. The other possibility is that you've got the amount of dodging and burning right, but it has affected too much or too little of the picture. It's easy to fix.

In the Adjustment Brush panel is the word Erase. This is actually a button which switches the brush from painting to erasing mode. Just like when you are painting an adjustment, make sure you first review the slider values—a high Feather and a low Flow will make your handiwork less noticeable—and then stroke the image to remove the local adjustment from that area.

A much faster way than clicking the Erase button is to use another keyboard shortcut—the Alt (PC) / Option (Mac) key. You hold down this key while you are stroking the picture and it makes the brush temporarily switch to erasing mode. It sometimes helps to switch on the Overlay (O) mask when you're doing this and see precisely which areas are targeted.

Also notice the check box called Auto Mask. This is a very smart feature which helps you restrict dodging or burning to an object or part of the picture. Once Auto Mask is ticked, begin brushing precisely on the specific detail or area that you plan

to adjust. Auto Mask then makes the Adjustment Brush sample that feature's color or texture, and as you continue to brush the picture you'll find that the dodging and burning will only affect matching areas.

Auto Mask is great when you need to target a certain feature while protecting its neighboring areas, but don't leave it switched on all the time. Its ability to target is diminished when an area contains lots of small detail or indistinct colors and textures, and you can get a nasty grainy or bitty effect with a mix of protected and adjusted detail. So use Auto Mask with care.

1 Switch the brush to Erase mode.

2 Use Auto Mask with care to target your dodging and burning.

3 Auto Mask lets you be lazy and use a big brush to target a specific area.

4 The final image has the face and sash brightened to draw attention to them, and brighter areas darkened to make them less distracting.

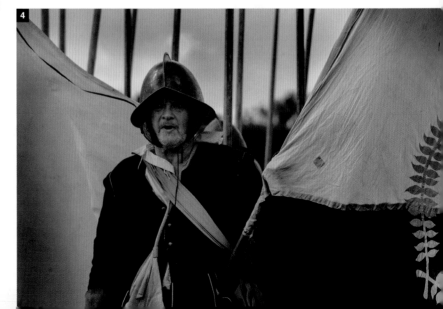

Highlights		100
Shadows		−100
Clarity		0
1 Saturation		0

Highlights		0.00
Shadows		58
Clarity		0
2 Saturation		0

Add emphasis with local contrast

1 Brighter Highlights and darker Shadows create a gentle contrast increase.

2 Contrast can be harsh, so first add a little.

3 Switch to Before / After view (Y) and zoom in on critical details.

When you want to draw attention to certain parts of a picture, or make them less obvious, you are not limited to lightening or darkening. Contrast can also be applied with the Adjustment Brush, so consider it instead or as well.

Adjusting local contrast works in two ways. In one sense it is just like dodging and burning—more contrast emphasizes that part of the picture while less contrast makes it less interesting. In another way, it's saying that while the image's overall contrast correction is fine, it isn't the right correction for specific features.

As usual, activate the Adjustment Brush (shortcut: K) and make sure you run your eye down all the sliders all the way down to Feather and Flow. This takes a fraction of a second and prevents mistakes. Remember the quick way to set any slider to 0 is to double-click its text label.

A gentle contrast change can be added by setting the Adjustment Brush's sliders so the Highlights and Shadows are in opposite directions.

The Adjustment Brush also provides a Contrast slider and this gives you a lot of control over the entire tonal range from white to black. Brushing with a positive Contrast value will increase an area's contrast and gives it a "crunch" that helps distinguish it from its surroundings.

The skill is to build up the effect gradually so no one spots what you've done. Don't increase an area's contrast so much that it seems out of tune with the rest of the picture, and another danger sign is when the change in contrast seems too abrupt. Remember to use higher Feather and lower Flow settings to make your artistry blend in.

Reducing contrast is usually easier to get away with. It's often most useful when an area cannot be darkened any more without becoming unrealistic or without unbalancing the picture's overall appearance. In such cases, dampen down the contrast and there will be less to attract the viewer's attention to that part of the frame.

4–5 Adding contrast has focused attention on the man's face.

48

Use a tablet

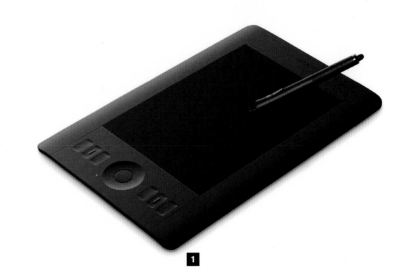

1

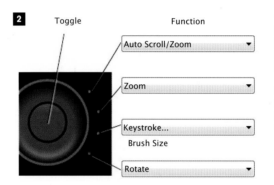

Dodging and burning with the Adjustment Brush is a classic use for a tablet-and-pen combination. That said, you do not absolutely need one, and for most of this book it makes no difference if you have only a mouse or trackpad, and all your dodging and burning can be done—and done well—without a tablet. But a tablet does provide one really significant benefit when you're dodging and burning: pressure sensitivity.

Pressure sensitivity works beautifully with the Adjustment Brush because the tablet senses how firmly you are pressing the pen, and Lightroom automatically varies the Flow. If you want to build up the effect gradually, only press gently as you stroke the picture. Press much more firmly to apply the brush with a higher Flow amount.

It's worth spending a little time practicing so that this becomes natural and intuitive. Try switching on the Overlay (O) if that helps you see how the pressure sensitivity works.

A tablet has other benefits too. When you want to remove the Adjustment Brush's effect from an area, there's an alternative to holding down the Alt (PC) / Option (Mac) key—use the pen's eraser end.

Dodging and burning involves a lot of moving quickly around the picture, and some people find a pen and tablet makes this easier. This is probably true, but is less so if you have a good mouse, with a trackball for example. It's certainly worth considering.

One downside of a tablet is that it requires desk space and competes with the keyboard and the

mouse for the best position in front of the screen. Be particularly sensible about where you place it because while a mouse or trackpad only exercises your wrist and fingers, a tablet uses your whole arm. So it potentially puts more strain on more joints. Experiment with a variety of setups and decide what works for you. I like—or find it worth the effort—to shove keyboard and mouse out of the way and position the tablet exactly where I always have my mouse. That's just me. Some people won't need a separate mouse, others use their pen instead, or you can find tablets which include a mouse or others with fingertip control. Just don't put up with a bad working posture. If you're not comfortable, how are you ever going to produce your best black and white?

1 Wacom's Intuos is one of the most popular graphics tablets. The pen's top automatically switches to Erase mode.

2 The dial can be customized for quick access to frequently used tools.

3 Painting with a mouse and flow at 100%, the effect does not build up subtly.

4 The pen, on the other hand, responds to how hard you press, even at 100% flow.

5–6 Darkening this area nudges the eye back toward the subject and isn't noticeable or unrealistic.

49

Use Clarity to bring out fine detail

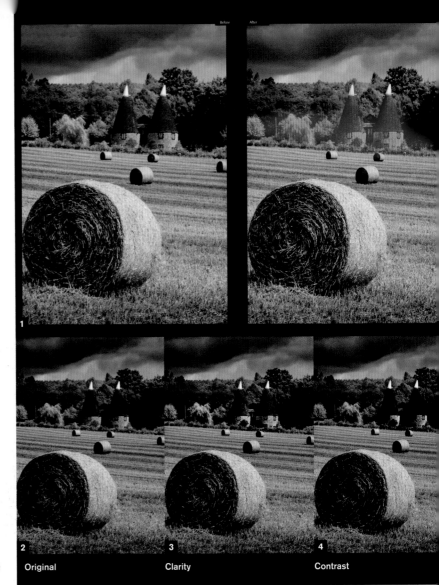

1 Use Before / After (Y) and the Overlay (O) to confirm where you are brushing.

2–4 Clarity has made the house a more noticeable part of the composition and much more naturally than Contrast.

Using contrast to adjust selected parts of a picture can make them stand out, or make them more subdued. Contrast stretches all the tones, and that can be just fine with some pictures, but at other times it can look rather coarse and brutal. So there's another contrast adjustment which often works better—and that is Clarity.

We readily understand what a "Contrast" slider must do, but what about "Clarity"? Other programs use terms like "Definition" and "Punch" which give a better idea of what it really does—defining and adding punch. What's more, it does this intelligently by adapting to the area where it is being applied.

As you brush with Clarity it identifies edges and details and changes the contrast around them, while leaving neighboring smoother areas untouched. Its contrast adjustment also works mainly on the mid-tones, so it tends to be less harsh than Contrast.

As usual, activate the Adjustment Brush (shortcut: K), review all the sliders down to Feather and Flow, and make sure Auto Mask is off.

But this time, notice the "Effect" drop-down box at the top of the panel and choose Clarity. By default, this preset will be set at +100, so the preset is a quick way to set Clarity so it emphasizes details.

Then paint away. Clarity can have a strong effect, so press gently if you are using a tablet and allow the adjustment to build up.

Also make full use of the Before / After split-screen view, or hold down the backslash key (\) to compare with how the image previously looked.

While you might decide to use Clarity all the time, don't forget Contrast. The two can work together with Clarity adding its punch but the effect being balanced by lower Contrast. Either set the sliders this way this before starting to paint, or paint part of the picture with a high Clarity and review the result. Something may stand out too much, so make sure the local adjustment circle is active—with the black dot—and then pull back the Contrast slider.

Clarity for softening

1 There is an Adjustment Brush preset called **Soften Skin.**

2 Brush only the areas you really want to affect. In the original, the girl's skin textures are obvious.

3 The trick is to keep skin tones natural.

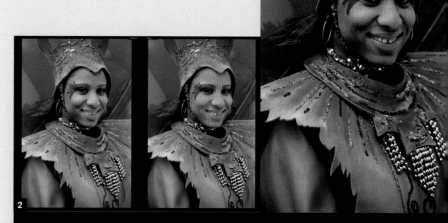

Clarity can define and add punch to part of a picture, cleverly adding contrast and making detail and features stand out. You can also use it make them less obvious too, when that is what you want.

As with all dodging and burning, activate the Adjustment Brush (shortcut: K), review all the sliders, and make sure Auto Mask is off. Set Clarity to a negative value and start stroking the picture.

One of the best applications of negative Clarity is to soften skin tones, and Lightroom includes a built-in "Soften Skin" preset which blurs wrinkles and other blemishes and makes them less defined.

Make sure that Flow is at a low setting, or that you press your stylus gently on the tablet so the effect builds up gradually. The more you brush, the more facial tones begin to appear impossibly perfect and eventually you can inflict the full-on plastic skin look that gives Photoshop a bad name.

When you are doing this kind of portrait retouching, don't forget to use the black-and-white conversion mix. Use the targeted adjustment tool and stroke upward on the face. This will brighten the reds, oranges, and purples and render them as similar shades of gray, making any differences and details less obvious.

✳ Some last thoughts on dodging and burning with the Adjustment Brush

Use the Adjustment Brush for specific areas which need different brightness or contrast corrections from the rest of the picture.

Use the Adjustment Brush to draw attention to key elements:

✳ Brightening or increasing contrast or clarity tends to make features stand out;

✳ Darkening an area or reducing its contrast or clarity usually makes it less noticeable;

✳ Making some features less distracting can direct attention to what's important.

Dodging and burning is an ideal application for a tablet and pen.

Brush up the effect gently so you dodging and burning isn't obvious.

Each time you start a new dodge and burn, always run your eye down all the sliders.

Use Auto Mask with care.

Remember the shortcuts:

✳ K to switch the Adjustment Brush on and off

✳ O to display and hide the Overlay

✳ Alt (PC) / Option (Mac) to switch to Erase mode

51

The digital graduated filter

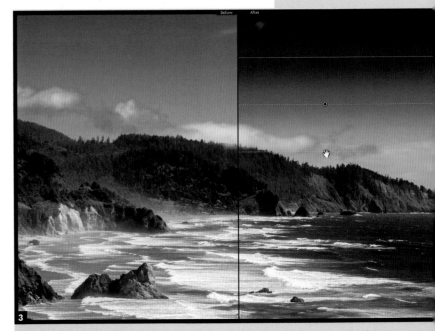

When you are taking a picture, you can put a grad filter over the lens and darken the sky, for example. This can help us capture detail in its very brightest areas and also push the eye down into the picture. Wouldn't it be great if we could do that digitally too?

Lightroom has a Graduated Filter tool (shortcut: M) which you can use in a very similar way. It has roughly the same sliders as the Adjustment Brush, so always run your eye down them and ensure they are all set how you want.

Then click near the edge of the picture, and drag it into the picture. You'll see there are three lines. One starts where you first clicked and it marks where the filter is at its full strength. Ignoring the middle line for a moment, the third line is where you stopped dragging and marks where the effect tails off to zero. So the distance between these inner and outer lines controls the graduation.

You can add as many instances of the Graduated Filter as you want. Just click the New button in the panel, and you'll see that all the other filters will now be marked as a small circle. Review the sliders, and drag the new filter over the photo.

On each filter's middle line is one of these circles, and you click a circle to select that instance.

A black dot appears to indicate it is active and you may now change its slider values, or press Delete to remove the filter.

You also change the filter's angle using this middle line. Move the cursor away from the circle and over the middle line. The cursor changes to a pair of arrows and you can then drag the line.

1 Activate the Graduated Filter by clicking this button.

2 Always review the slider values. Here, Exposure is set to a negative value to produce a darkening effect.

3 The farther apart the inner and outer lines are, the smoother the graduation is.

4–5 Alter the Graduated Filter's angle by dragging the filter's middle line.

6–7 Gently darkening the sky pushes attention down onto the landscape.

✳ Keep Your Filter Lined Up

One trick is handy if you want the filter to be parallel to the side of the picture: Just hold down the Shift key as you drag the new filter onto the picture.

52

Using grad filters to make clouds and skies stand out

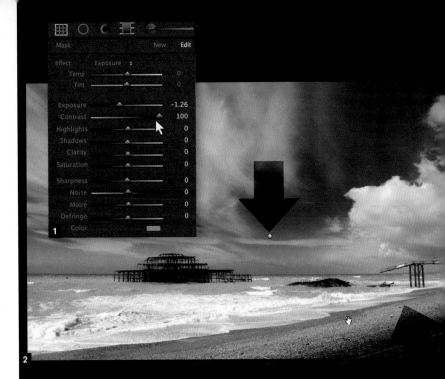

1 Use the Graduated Filter sliders individually or in conjunction.

2 One instance of the Graduated Filter darkens the sky, while another darkens and adds contrast to the corner.

3 More Clarity and more Contrast, while also darkening the Shadows.

The Graduated Filter tool is great when you are working on landscape photos. It's especially intuitive if you have ever used ND Grad lens filters, but its settings are so flexible that it's like having a huge wallet of ND's and other types of filter too.

One thing you can do in Lightroom is combine adjustments in a single application of the Graduated Filter. You may want to darken part of the frame, which might make it less obvious, so boosting its contrast at the same time may keep the composition in balance.

Don't be reluctant to use more than one filter. One might darken the whole sky, but then you might drag a second one from one particularly bright corner.

Another use might be to darken the very bottom of the picture. Rather like darkening a sky, this can give the picture a base and push the viewer's attention toward the subject. If you do this subtly, no one will ever notice.

The Graduated Filter tool doesn't just darken skies. In fact, sometimes simply darkening the sky can be a rather blunt tool. You may find that brighter clouds may be made an unnatural gray, or interesting cloud detail may appear less obvious if you've made that part of the frame darker. One way around this is to darken less, and instead apply Contrast or Clarity.

It's more than just a workaround—it's often a way to stamp your creative interpretation on the scene. For example, set Clarity to +100 and then drag the filter down across the sky. If you recall Clarity's

alternative names, Definition or Punch, you won't be surprised to see the cloud detail now stands out quite a bit more.

Sooner or later you are going to wreck the sky, but you can often get away with a second Clarity filter, and possibly a third or fourth. Just keep clicking the New button in the Graduated Filter's panel and dragging the filter downward across the sky. You can also balance the effect by reducing Contrast or Exposure.

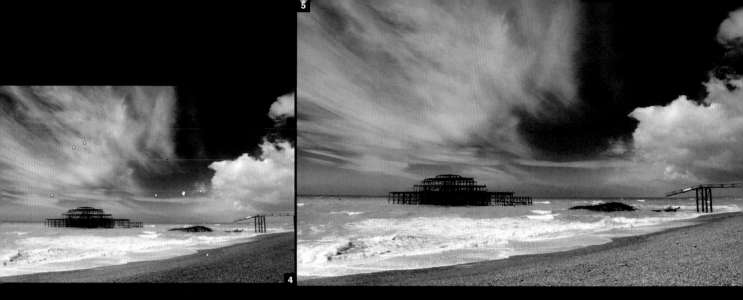

4 This sky was still natural-looking after having six applications of the Graduated Filter.

5 The "before" version's sky is okay.

6 Make the most of interesting clouds by applying Clarity with the Graduated Filter. If you hadn't seen the "before" version, wouldn't you believe this was how the scene looked in reality?

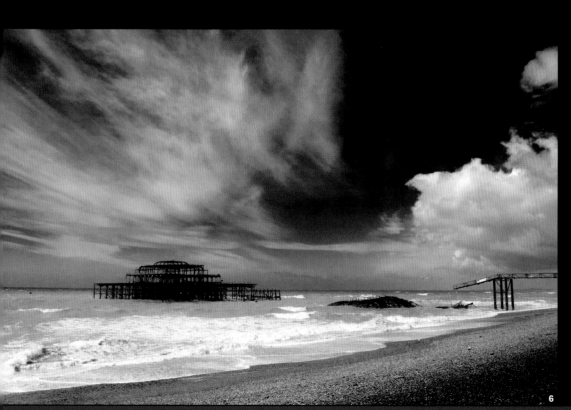

53

Burning in the corners & edges

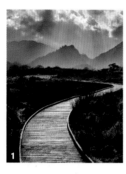

1 Notice how this crop leads the eye out of the picture to the right and at the bottom.

2 It's always subjective, but a less-tight crop leads the eye along the boardwalk and into the landscape.

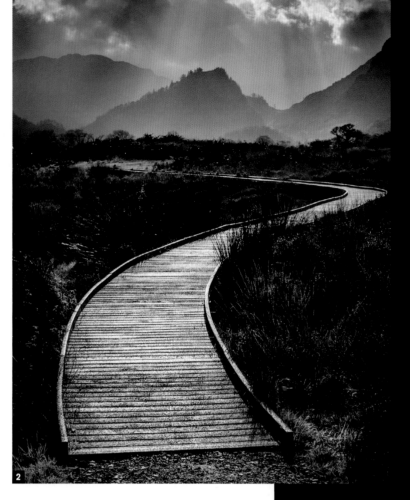

Before sending a black-and-white picture to the printer, it's often a good move to pause and spend a moment or two reviewing its edges. A little bit of "edge burning" (darkening the edges) may help hold the picture together.

Once the photograph goes onto paper, it is usually surrounded by a pure white margin that is not very different in tone from some of the image's brightest areas. If these bright areas lie near the picture's edge and merge with the white margin, the eye tends to be directed toward them and out of the frame. The white border competes for attention with the picture. So just run your eye around all the edges and look for distractingly bright features.

Sometimes these weak edges can be self-inflicted by cropping the picture. Here, in the closely cropped version the boardwalk, which should lead us into the picture, it seems to pull us down and out of the scene. There's a similar distraction where it curves to the right. In this picture's case, a less tight crop means these two brighter areas are contained.

In other cases, you can crop tightly and eliminate bright distractions lying near the edges without

harming the picture. But that's not always so, and in this picture is another very bright area—the sky—which cannot be cropped without sacrificing an interesting aspect of the scene.

In such cases, reach for the Adjustment Brush or the Graduated Filter and apply a little edge burning. Activate the brush or filter and set its sliders so they subdue the area—less Exposure, less Contrast, darker Highlights. Then drag into the image over the edge area.

Alternatively, consider the Post Crop Vignette, which is down in Lightroom's Effects panel. Its main purpose is creative—darkening or lightening from corners—but it can also be used to counter brightness in the corners and around the edges.

3 4 5 6

3–4 A Graduated Filter can subtly reduce the attention given to the bright cloud detail by reducing its contrast and highlight brightness.

5–6 Notice how darkening the corners pushes your attention back into the body of the picture.

Post–Crop Vignetting		
Style	Highlight Priority ⁑	
Amount		-26
Midpoint		50
Roundness		0
Feather		50
Highlights		0

7

7–8 A black-and-white photo is often held together by a little edge darkening.

8

54

Creative vignettes

Vignetting can be an alternative way to dodge and burn the edges of a picture, but its main purpose is creative. After all, the term comes from the French word for vine, originally referring to decorative borders in books; and vignetting's main role in photography has always been for producing fancy effects. So let's explore a few.

Lightroom's vignetting feature has five sliders. Amount is the strength, while Midpoint controls how much of the image gets affected. Dragging this Midpoint slider to the left brings the vignetting in toward the image's midpoint. Roundness refers to how the corners will be shaped; Feather to how the effect tails off; and the last slider, Highlights, can be used to make bright details stand out in the vignette areas.

Now you know what the sliders do, just experiment with different permutations.

1 Increasing the Amount lightens the image edges and produces a classic vignette effect. Exaggerate this look by dragging the Midpoint in, increasing the white edge, and then making the corners less round by dragging Roundness to the left.

2 You can even create a circular crop by pushing Roundness right up to 100. Here, Feather is set to 0 to make the effect even more obvious. Photographs don't have to be square or rectangular, and you'll find plenty of 19th-century pictures that weren't!

3 To produce a rounded corners look, drag the Roundness a little to the left and set the Feather to 0 so the edges are sharp.

4 Burn in the edges with a negative Amount value and a little feathering.

5 Other effects can be handy. Paint Overlay adds black-and-white noise to the edges and can produce a flat look typical of old and degraded lenses.

55

Soft-focus effects

3–4 Use the Adjustment Brush to paint the soft focus onto the picture.

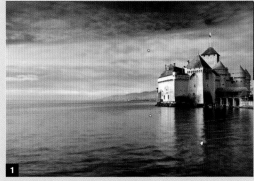

1–2 Multiple applications of the Graduated Filter can produce an effect similar to a tilt-shift lens or older, degraded lenses.

Another creative effect you may want to try is soft focus. Applied gently to limited areas, it can make distracting features less obvious; or you might apply it much more enthusiastically. It can also work well on its own or in conjunction with other treatments like vignetting or toning. Play!

In general it's better to apply soft focus as a local adjustment. In some cases, the Graduated Filter is ideal, so activate it by clicking the tool in Develop's right-hand side, or use the shortcut M. Set Sharpness to a negative value and, as always, run your eye down the sliders and ensure they are all correct. Then just drag the filter from one side of the picture in exactly the same way as when you're dodging and burning, and add as many additional instances of the filter as you wish.

With other pictures the Adjustment Brush is the better choice, and again it's just a variation on dodging and burning. Activate it by the keyboard shortcut K (which also closes it), set Sharpness to a negative value, review the other sliders and make sure Feather is 100, Flow is 50 or lower, Auto Mask is off—and you're ready to go. Then just paint the softening effect onto the picture.

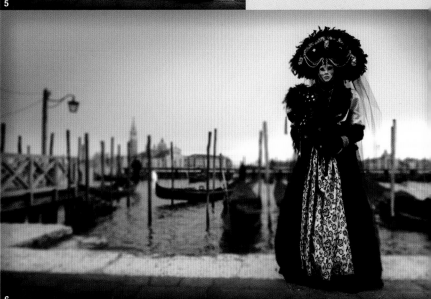

5–6 Soft focus often works well with vignetting and a gentle color tone.

56

A color tone

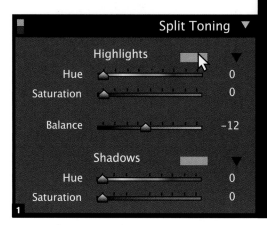

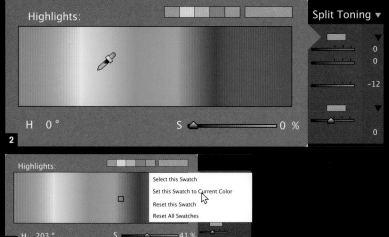

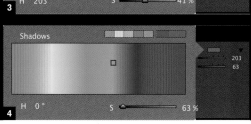

Black and white has never been limited to pure shades of gray. In photography's early days, a variety of colored tones resulted from the materials available at that time. Once consistently-neutral tones did become possible, photographers chose to deliberately add tones for artistic reasons. It's a great finishing touch that you should keep in mind.

In Lightroom, go to the Split Toning panel in Develop's right side and notice that this allows you to set separate colors in the highlights and the shadows. But instead of dragging the sliders, get started by clicking the rectangular patch to the right of the Highlights label.

Clicking this colored rectangle reveals the Color Picker and makes the cursor change into a sampler. Hold down the mouse's left button and drag the cursor around the color spectrum. As you move the cursor, the sampled color is applied to the picture.

Notice too that the Color Picker has some swatches along its top. If you're feeling lazy, just click one of these and its color will be applied to the picture. You can also use these swatches to store a

color that you've just sampled from the spectrum. Just right click one of the swatches and choose Set this Swatch to Current Color.

Repeat the process with the Shadows by clicking the rectangular patch to the right of the Shadows label. But here's another trick: This time, hold down the left button and drag the color sampler as before, but carry on dragging outside the colored spectrum's bounds. You'll see that the sampler can detect colors from anywhere on the screen—from the picture's highlight tones, from other pictures in Lightroom's filmstrip, for example, or even from other programs' windows. This is great if you're trying to apply a consistent tone or match the toning to other pictures or content.

5

1 Drag sliders or use the Color Picker.

2 Drag the cursor around the spectrum area to apply colored tones.

3 This makes it easy to later reuse that color on another image.

4 The color sampler picks up color from outside the spectrum area, which is great when you want to apply the same tone to the highlights and the shadows.

5 Blues can enhance a scene's coldness.

6 Sepia hints at warmth or implies past times.

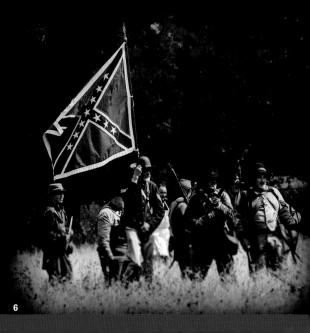

57

Split toning

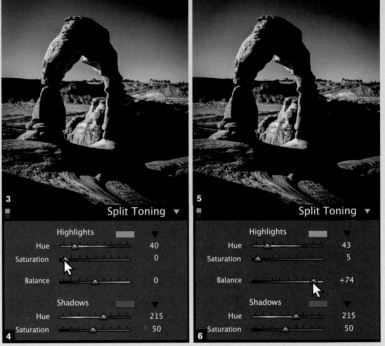

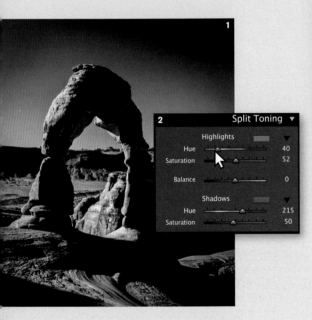

1–2 Drag the Hue slider to make the colored tone begin to appear. Sepia highlights and blue shadows are a dependable combination.

3–4 A split-tone effect can leave one end of the tonal range neutral. For instance, this image is starting to appear too blue.

5–6 Use the Balance slider to control how much of the image takes on the shadow and highlight tones. Now the blue is concentrated in the shadow tones.

Instead of applying a single color across the whole tonal range, you can add one color in the highlights and another to the shadows. This is known as split toning.

Split toning is very intuitive and it is easy to experiment, but a combination that almost always works well is sepia highlights with blue shadows. This time, instead of using the color rectangle, start by dragging the Saturation slider under Highlights—anything greater than 0 means some color will be displayed on the picture. Next, drag Highlights' Hue slider to around 40 and the image should be given a rich sepia tone. And then drag the Shadows' Saturation slider to its right, and move the corresponding Hue slider into the range of blues, 215 for instance. You now have a split-toned picture—it's that easy.

You can also produce a subtle split tone effect by coloring either the shadows or the highlights, but leaving the opposite end of the tonal range in black and white. For instance, assuming we want to tone the shadows blue but have neutral highlights, we would drag the Highlights Saturation slider to 0 or double click its text label. Then set the Shadows sliders to blue, as before.

At first, this blue tone isn't really limited to the shadows. It spreads a long way into the mid-tones. But notice there is also a Balance slider, and this is used to control how the Split-Toning adjustment defines the shadow and highlight tones.

One way to think of Balance is that shadows are on the left, highlights to the right. Drag the slider to its left and more of the tonal range will be treated as shadows—in this case given the blue tone. Dragging the slider to its right will make Lightroom treat most of the tonal range as highlights. For example, +95 means that most of the picture will be defined as highlights, which are set to 0% Saturation, and only the very darkest tones will pick up the blue shadow tone.

58

2

Presets

1 Move the mouse over a preset and the Navigator panel shows a preview of its effect. Notice how this preset renders the US flag's reds and blues.

2 The key aspects of this treatment are the tone, the vignetting, and the grain.

Presets are a great way to apply a look or a style to your pictures. They can be quick and easy, eliminate repetitive work and so make best use of your time, and they allow you to produce a series of photos with a matching appearance. But they need to be used with caution. It's best to create your own presets.

Plenty of presets are available online, and some are specifically for black and white. Do be cautious though, because while presets may be named after TMax 100, FP4, or other film stocks, experienced B&W film users would ridicule such claims. Certainly it's a mistake to pay for presets—there are free ones which are every bit as good as any which are advertised for sale. Even if you avoid being fleeced, presets are not going to help you learn for yourself, and the big risk is that you end up applying one preset after another and not thinking about what you're doing. So only download a few presets from well known experts, keep your money in your wallet, and learn to make your own presets.

The starting point is when you've adjusted a picture and decide you've given it a look that you would like to keep handy and apply to other pictures in future.

Now, simply click the + button at the top of the Presets panel.

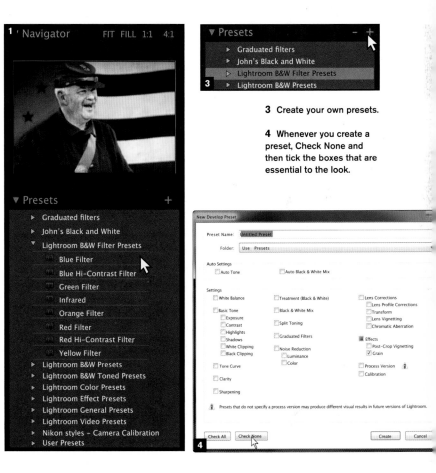

3 Create your own presets.

4 Whenever you create a preset, Check None and then tick the boxes that are essential to the look.

59

Adding grain

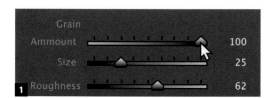

1 It's easy to experiment with big lumps of rough grain, or make it fine and subtle.

2 Grain's effect is difficult to judge, so consider using Before / After view.

3 Try zooming out to evaluate how grain will appear when you print the photo.

Film grain has often divided black-and-white photographers. Some detested it and chose their film stock and chemicals to minimize it, while others liked graininess and saw it as a quality. It probably depended on the kind of photography you most admired, and the gritty "Tri-X look" or "HP5 look" was certainly obvious in great images created by mid 20th-century photojournalists. Of course, digital photography doesn't have film grain and high ISO noise is generally unwelcome, but you can always add grain as a finishing touch—a nod back to this film tradition, or simply because you like the look.

Lightroom has a group of Grain sliders in Develop's Effects panel. Amount is the strength of the grain, while Size and Roughness are self-explanatory.

The best thing to do with Grain is to experiment. Adding grain is that easy—just see if a certain combination of sliders produces an effect that you like. On the other hand, it's hard to accurately evaluate the result, so when you're adding grain always consider switching to the Before / After view with the keyboard shortcut Y.

What makes evaluating grain so difficult is that what you see on screen is not necessarily what you will see on a print. Grain that looks very obvious on a large computer monitor may appear almost indistinguishable when it's squeezed on a 5×7 or 10×8 inch print. While one trick is to estimate the final appearance by zooming out, you're still trying to compare a screen which has such very different resolution or dots-per-inch from the printer, so you're always going to be guessing how it will turn out. The only way to definitively evaluate the graininess is to look at the print.

4–5 Grain can add a
photojournalistic touch
to some pictures.

6 The other reason
to add grain is as a
special effect.

60

Colorizing

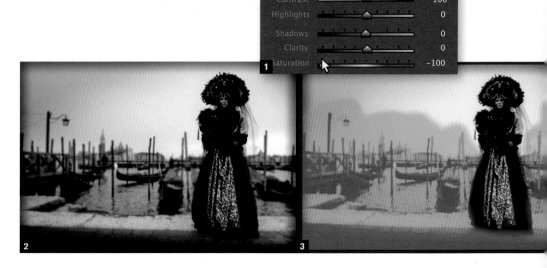

Exposure	0.00
Contrast	100
Highlights	0
Shadows	0
Clarity	0
Saturation	-100

Another fun technique to try is colorizing—i.e., taking a black-and-white photo and coloring certain features. It's another style that's deeply rooted in photography's early days, and hand-coloring prints was quite common until color negative film became available.

Lightroom offers essentially two methods. The first we'll examine is the simplest and involves removing some but not all the original colors, while the second uses the Adjustment Brush to apply color to the black-and-white photo, and is a bit more creative.

Starting with your corrected color picture. Instead of going to the B&W panel, you should go to the Saturation panel nearby. Drag all its sliders down

to 0. Next, go to the Luminance panel and use the targeted adjustment tool to change the Luminance sliders exactly as if you're fine tuning a black-and-white conversion.

Then go back to Saturation, decide the color(s) which you want to retain in the photo, and drag those sliders to the right. You now have a mostly B&W picture with some elements of color.

It's likely that your chosen color will not be just in the feature you want to pick out. Clear up any stray color by activating the Adjustment Brush (K) and setting its Saturation slider to -100. Review the other sliders as usual, and paint over the areas of the picture which shouldn't be colored.

1–3 Set the Adjustment Brush's Saturation to -100, and the Overlay mask (O) can show where you've painted. This saturation method produces a B&W image with some of the original color preserved.

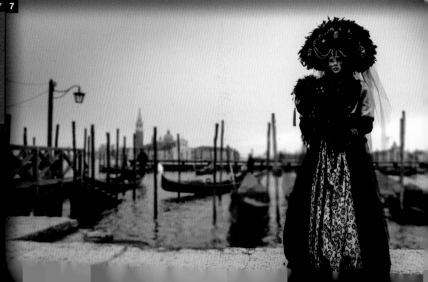

4–6 Leave one or two colors so they retain some original color.

7 A problem with this method is that a color is seldom restricted to the features you want to have colored.

61

Colorizing, option two

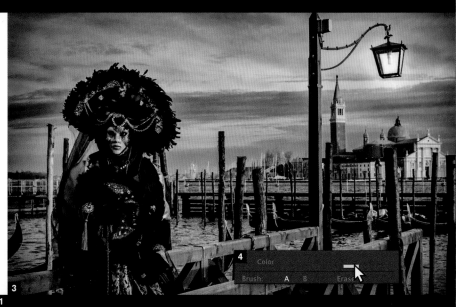

1 Try adding a colored tone as a base color.

2 Target features more precisely using Auto Mask.

3–4 The advantage of this painting method is that you can select any color you wish, and are not limited to those in the original picture.

The other way to colorize a picture is only a little bit more difficult, but it is much more satisfying. Maybe that's because it's more like painting a real photographic print, or it could be that you are choosing which colors to add.

This time, the starting point is a photo that you've already made black and white, and maybe added a little color in the Split Toning panel, as this base tone can also provide a hint of age or timelessness to the picture. Activate the Adjustment Brush (K) and click the colored rectangle to the right of the Color label. Select the tone you want, review the other sliders as usual, and paint on the feature you want to color.

As always, paint with a low Flow value if you're using a mouse, or press gently if you've got a

tablet and pen. This will let the color build up.

When you want to paint something else in a different color, click the New button in the Adjustment Brush panel, select your color, and paint away. You can add as many colors as you wish—it can be additive!

5 Set the Adjustment Brush's sliders to 0 and select a color.

6 You can paint a softly defined area such as the one around this lantern.

62

Batch converting a whole shoot

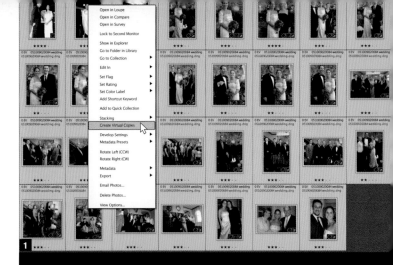

1 Select all the pictures and create virtual copies.

2 Lightroom distinguishes Virtual Copies from the original with a turned-up corner.

While we can often work on one image at a time, we don't always do that in reality. We may have taken a lot of pictures and want all of them in black and white, or we decide we'd like both color and mono versions. Luckily, that's easier than ever.

Select all the color pictures in Lightroom's grid view (G)—not in the film strip. Then use the menu command Photo > Create Virtual Copies, or right click a thumbnail picture and choose Create Virtual Copies.

Keeping the Virtual Copies selected, press the V shortcut to apply a default black-and-white look.

With the Virtual Copies still selected, open up the Metadata panel and find the Copy Name field. Change this to something meaningful to you. This makes it easy to find these pictures later, and you could include this Copy Name in filenames if you need to share the black-and-white versions. When you're handling lots of pictures, it's good to be organized!

You now have color and black-and-white versions of every picture from the shoot or event, and without them eating up any hard drive space. The black-and-white copies can be individually fine tuned, or alternatively leave them selected if you'd prefer to adjust them as a batch.

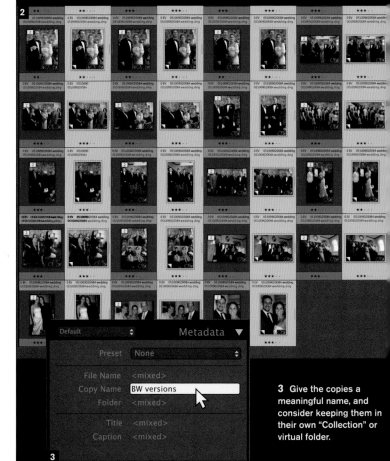

3 Give the copies a meaningful name, and consider keeping them in their own "Collection" or virtual folder.

63

Adjusting lots of pictures at once

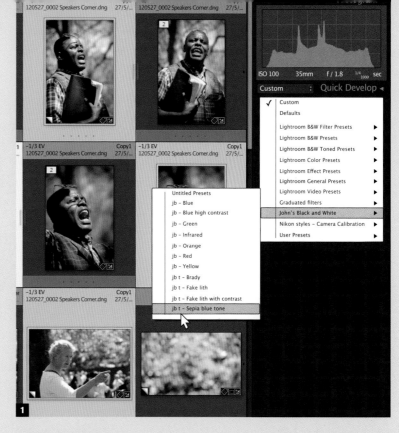

When you want to make identical adjustments to a batch of pictures, Lightroom's Auto Sync is a very handy feature. It makes each Develop adjustment apply to all the other images that are currently selected, and it's the fastest way to work in Lightroom. Use it whenever you're working with lots of pictures.

To work in Auto Sync mode, select the pictures in Lightroom's grid or in the filmstrip, and go to Develop. At the bottom of its right hand side is a button which defaults to "Sync," but it has a small switch which changes it to "Auto Sync."

Once Auto Sync is on, it's best to leave the filmstrip visible (F6) so you can readily see that multiple images are being adjusted. It's an important reminder that helps prevent mistakes!

Now just adjust the picture. For example, apply a Split Tone and notice how it applies to the picture on screen and also to those you've selected in the filmstrip. That's what Auto Sync does.

Auto Sync is a wonderful time saver and the more time you save by batch processing large numbers of pictures, the more of the day remains so you can give individual attention to images that stand out from the crowd. Speed is not for its own sake.

1 In Library's grid, you can apply a preset to all the selected pictures or virtual copies.

2 The Sync button can be switched to Auto Sync.

3 Display the filmstrip while you're using Auto Sync.

64

Photoshop

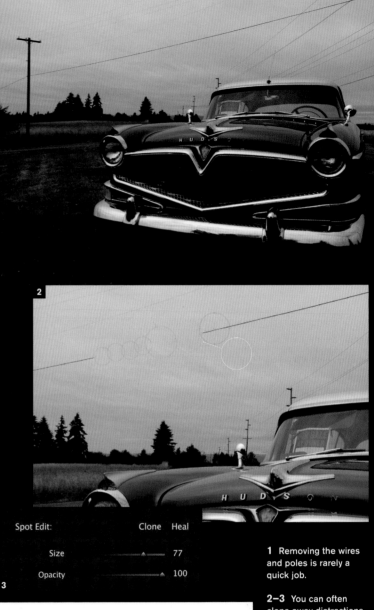

At one time, B&W enthusiasts would have automatically resorted to Photoshop to make their photos black and white, and then used one of its 20 or so alternative methods. Nowadays though, a program like Lightroom offers a streamlined way to work and comes at a fraction of the price. So if you are happily using Lightroom or Aperture or other programs to do black and white, what might make you switch to Photoshop?

The broad answer is that programs like Lightroom or Aperture are designed to handle what most people typically do with photographs (notice the plural) while Photoshop has the power to do almost anything you can imagine to a single picture. It remains the Swiss Army knife of image editing and can handle the full gamut from black and white to preparing pictures for printing presses, even 3D and video rendering. While Lightroom's dust-removal tool, for example, can often be pressed into service to hide contrails, telephone wires, and other distractions, serious cloning lies outside its scope. It's on such occasions that you need Photoshop. And while you're over in Photoshop, you may as well do the B&W conversion too.

While we can only skim the surface of the different image-editing tasks that Photoshop can do, consider a few things that might make a photographer choose it. You might want to make people slimmer or change the shape of a jaw or cheekbone, replace one person's face in a group picture, or combine images with text. Alternatively,

you might do an HDR blend or exploit Photoshop to stitch a huge panorama. And one could continue in the same manner, listing other broadly mainstream photographic activities that need a pixel editor like Photoshop or Photoshop Elements. But there is one common theme here that is really important: Not one of these many diverse reasons is fundamentally about making pictures black and white.

1 Removing the wires and poles is rarely a quick job.

2–3 You can often clone away distractions by pretending they are dust spots. But surely life is too short.

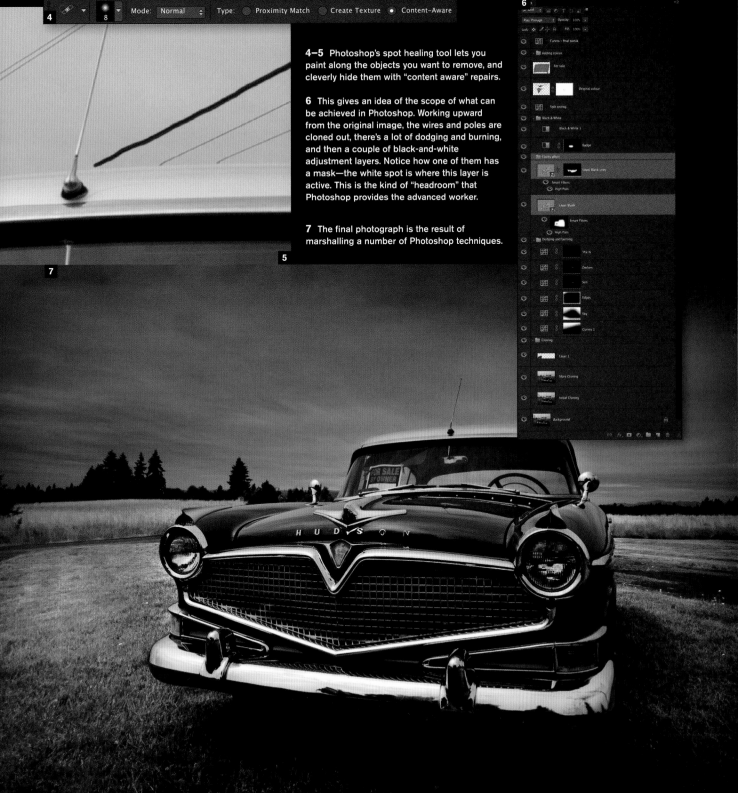

4 Mode: Normal Type: Proximity Match Create Texture ● Content-Aware

8

6

4–5 Photoshop's spot healing tool lets you paint along the objects you want to remove, and cleverly hide them with "content aware" repairs.

6 This gives an idea of the scope of what can be achieved in Photoshop. Working upward from the original image, the wires and poles are cloned out, there's a lot of dodging and burning, and then a couple of black-and-white adjustment layers. Notice how one of them has a mask—the white spot is where this layer is active. This is the kind of "headroom" that Photoshop provides the advanced worker.

7 The final photograph is the result of marshalling a number of Photoshop techniques.

5

7

65

Photoshop, continued

Occasionally, a black-and-white conversion mix or recipe won't be right for every part of the picture, no matter how carefully you've dragged individual sliders. Your best efforts reveal interesting tonal differences in most of the frame, yet in some areas different colors are rendered as identical shades of gray. One these occasions, this is when you might use Photoshop for a specifically black-and-white workflow, because it can apply more than one black-and-white adjustment and target separate image areas.

First, add a black-and-white adjustment layer and fine tune the conversion for the entire image. In the Layers palette, click the New Adjustment Layer icon and pick Black and White. This method is the best way to do B&W in Photoshop and is similar in concept to Lightroom and other tools with sliders which map colors to grayscale tones. The small hand is a targeted adjustment tool or on-image tool, just like in Lightroom.

The ideal B&W conversion for the face involved dragging the Reds slider to the right, but it meant that the flowers seemed to merge with the hair. Changing the conversion mix to reveal the flowers was difficult because it also meant more skin tones were shown in her face. In Lightroom alone, you would have to find a compromise, but Photoshop allows you a second chance.

1 Here it's important that the black-and-white version conveys her looks and the intricacy of the carnival costume.

2–3 Add a Black & White adjustment layer in the Layers palette.

4 Reds are rendered as lighter grays, ideal for making skin look soft.

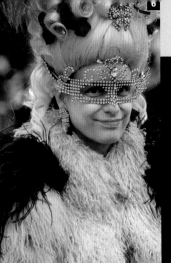

5
6

✳ Select Specific Areas

In the Layers palette, activate the image layer and make a rough selection of the troublesome area, in this case the flowers. Then add another black-and-white adjustment layer as before, and adjust the conversion recipe as normal. Notice how the adjustment layer has a mask that is identical to your selection and which targets that layer's conversion on the area shown in white.

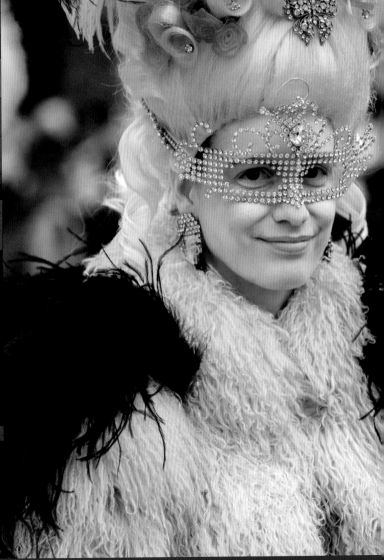

Layers

Kind

Normal — Opacity: 100%

Lock: — Fill: 100%

Black & White 2

Black & White 1

Background

7

5 The face looks fine, but where are the flowers?

6 The flowers are there, but now her skin looks rough and the same shade as her lips.

7 One black-and-white adjustment targets the very top of the picture.

8 A separate black-and-white conversion mix darkens the reds and oranges in the top part of the frame and renders more detail in the flowers.

9 The final picture shows gentle tones in the face, but also lets you see the detail in her costume.

Properties

Selective Color

Preset: Custom

☐ Tint Auto

Reds: 50

Yellows: 42

Greens: 90

Cyans: 50

Blues: 0

Magentas: 0

8

9

66

Black & white panoramas

To create a black-and-white panorama, leave the B&W conversion until after you've stitched the panorama in Photoshop, and can work on the combined image.

Shooting panoramas is not difficult and you don't need any special equipment. Ideally you would have the camera on a tripod, but if you use a faster shutter speed it's not essential. It's also best to choose a lens which doesn't have much distortion. Then point your camera at the brightest area that is going to be in your panorama and make a series of test exposures. Once you know what exposure combination retains highlight detail, set the camera's exposure to manual and switch off autofocus.

It's best to shoot from left to right, so when the pictures are on computer they'll be line up naturally. To help Photoshop stitch the final image, make sure shot overlaps by about a third, and work reasonably quickly to prevent the clouds or other objects moving between exposures.

I like to use Lightroom's stacking feature to group these component frames and apply a color label. This guards against the risk that I'll accidentally delete a frame.

Correct the pictures using Auto Sync, so they all have identical adjustments. Dust spots, for example, tend to stay in the same location and are ideal for correcting at a batch. When you're done, go to Lightroom's grid, right click a thumbnail, choose Edit In, and then Merge to Panorama in Photoshop.

This then launches Photoshop's stitching

1 Correct color and make other adjustments first, then send to Photoshop.

2 Cylindrical tends to be better for wider panoramas.

feature. Auto works pretty well, but with wider panoramas, choose Cylindrical and click OK. Photoshop then crunches the pictures and combines them into a multi-layered document. Use the menu command Layer > Merge Visible, and save your picture.

Sometimes you have to do more to the panorama. Edit > Transform can help with rotation problem, and its Warp feature is great for sorting out slightly wobbly horizons.

Back in Lightroom, do the black-and-white conversion as normal. Or just add a black-and-white adjustment layer in Photoshop and use its targeted adjustment tool in the same way as in Lightroom.

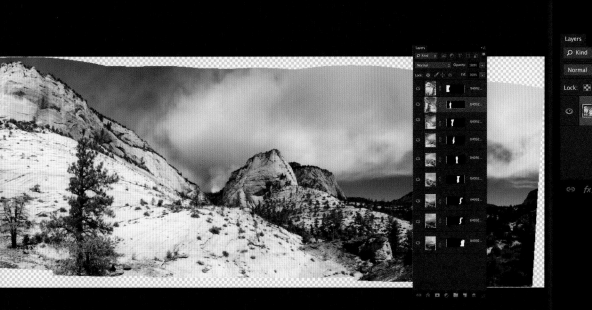

3 Consider using Photoshop's amazing Edit > Content Aware Fill to create realistic sky when the stitching has left awkward gaps.

4 From the Layers palette, create a new Black & White adjustment layer.

5 Just one of Photoshop's many capabilities is stitching huge panoramas.

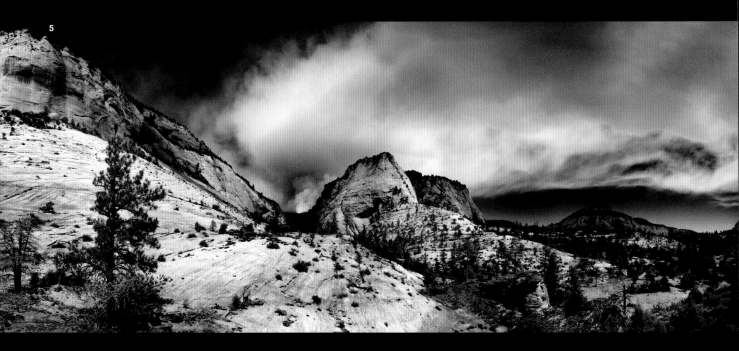

67

Black & white HDR

To create a black-and-white high dynamic range image, leave the B&W conversion until after you've done the HDR blending.

Although HDR blending requires Photoshop, you can keep a surprising amount of the work purely in Lightroom (version 4 and above). Lightroom needs to send the pictures to Photoshop or to a dedicated HDR application like Photomatix, but they only perform the HDR blending and everything else can be handled in Lightroom.

The workflow is quite similar to creating panoramas except there is one big difference—don't adjust the HDR frames first. Selecting them in Library, right click one and choose the command Edit In > Merge to HDR Pro in Photoshop.

Over in Photoshop's HDR Pro dialog, set the Mode to 32 bit output and place the white point on the very brightest part of the picture. Click OK.

Do nothing else in Photoshop. Just use File > Save As and then choose TIFF as the file type. Photoshop asks you to confirm that you want a 32-bit file—one that records each pixel's brightness with 32 bits of data. Accept this, click OK, and close the file.

Return to Lightroom and you'll see that it has automatically cataloged the 32-bit TIF file. You can then adjust the photo in Develop like any other picture and produce the black-and-white conversion. It's HDR B&W made easy!

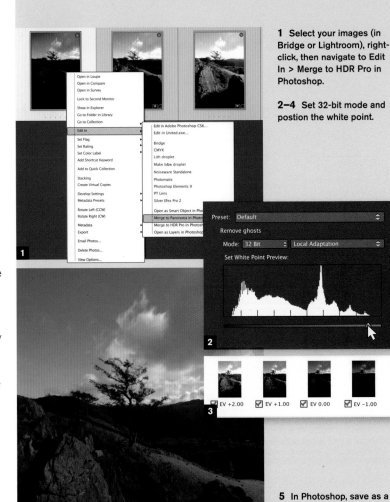

1 Select your images (in Bridge or Lightroom), right-click, then navigate to Edit In > Merge to HDR Pro in Photoshop.

2–4 Set 32-bit mode and postion the white point.

5 In Photoshop, save as a 32-bit TIF file.

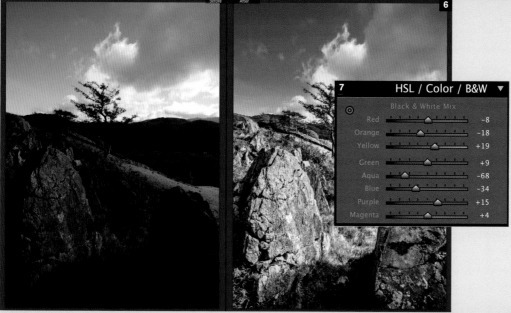

7 HSL / Color / B&W ▼

Black & White Mix

Red		−8
Orange		−18
Yellow		+19
Green		+9
Aqua		−68
Blue		−34
Purple		+15
Magenta		+4

6–7 Do the black-and-white conversion in Lightroom.

8 There's no need to clean up the dust spots and other faults of the original frames.

9 Apart from a quick visit to Photoshop, the final HDR image has been mainly processed in Lightroom.

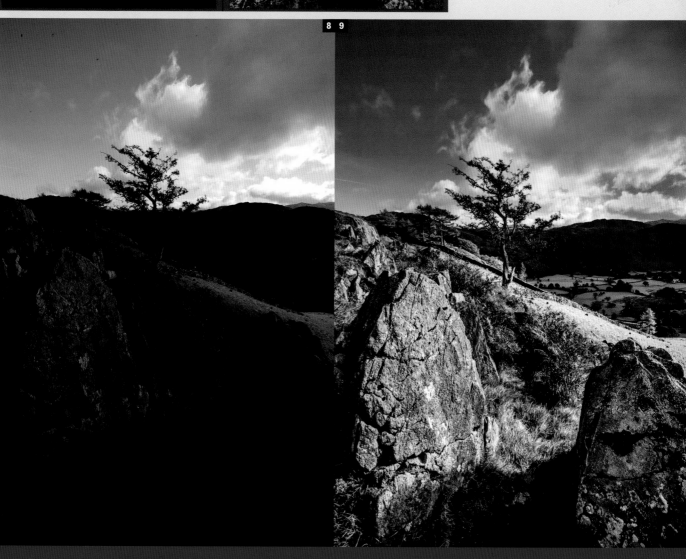

Chapter_ 04

Silver Efex Pro

68

Try a dedicated B&W plugin

If you do a lot of black and white, consider trying a specialist B&W plugin. Currently, the best known one is Silver Efex Pro (SEP), which we are going to examine in some detail—but Topaz B&W Effects also has a following. You may find either a worthwhile extension to your digital darkroom.

These plugins provide a very tightly focused set of features. This means you don't need to remember which of Photoshop's 20 or so alternative methods you should be using (the best being the Black & White adjustment layer) and you don't need to learn the other Photoshop techniques that you might need, such as selective adjustments or adding borders. They are all built into SEP, and are uncompromised by the needs of color photographers. This ease of use is a big benefit.

Some also feel they get can better quality B&W from SEP than from Lightroom or Photoshop. It's doubtful though. The trouble is, you are manipulating exactly the same image data, so there should be no difference between what skilled hands can achieve with each program. It may though be easier to reach a certain level of quality and expressiveness.

But it does make sense that a different tool makes you approach a task with another way of working. We could paraphrase Ansel Adams' famous likening of the B&W negative to the score and the darkroom print as its performance, so maybe using a black-and-white plugin like SEP is like playing the same notes but with totally different instruments. You'd expect different, possibly better results.

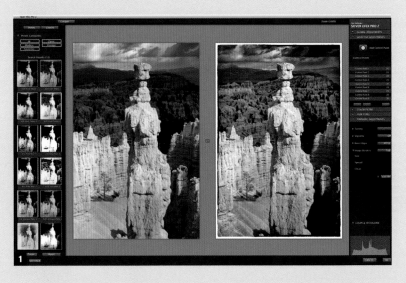

Of course, you do not need plugins to do great black and white. They are an option, even a luxury. Still, don't we all enjoy our little luxuries?

1 Nik's Silver Efex Pro is probably the best dedicated B&W plugin currently available.

69

Best ways to launch the plugin

1 If you own Lightroom but not Photoshop, right-click an image and choose Edit with > Silver Efex Pro.

2 If you own Photoshop, convert the image and any retouching layers to a smart object before going to Silver Efex.

3 In Photoshop, launch Silver Efex Pro from the Filters menu.

These black-and-white plugins do not start by themselves. You launch them from the host image-editing program—Lightroom, Aperture, Photoshop, or Photoshop Elements. So you start by making whatever color corrections the picture needs, and it's then that you switch to the plugin.

It is broadly the same way in each program, with the notable exception of Photoshop. In Lightroom, you right-click the picture and choose Edit with > Silver Efex Pro; in Aperture you right-click and choose Edit with Plugin > Silver Efex Pro; and in Photoshop Elements, it's Filter > Nik Software > Silver Efex Pro. After doing its magic, Silver Efex Pro returns a TIF file to your image-editing program, which is where you print or output the final picture. In these cases, you're out of luck if you ever want to fine tune the treatment or see what you did—you would have to start again.

On the other hand, those who own the full version of Photoshop can take advantage of "smart objects," a special kind of pixel layer which wraps and contains other image data. Your Silver Efex Pro adjustments will then be applied to it as a "smart filter." This means they remain editable, and so in later Photoshop sessions you just double-click the smart filter to restart SEP and change your settings. This flexibility, and also being able to copy your settings to other pictures, greatly outweigh the bigger file sizes.

For Photoshop owners, the ideal workflow is different depending on what programs you use.

- If you start from Lightroom, right click the picture and choose Edit as Smart Object in Photoshop. Once the picture is in Photoshop, choose the menu command Filter > Nik Software > Silver Efex Pro.
- From Aperture, send the picture to Photoshop. In Photoshop, choose Filter > Convert for Smart Filter, and then Filter > Nik Software > Silver Efex Pro.

If you are starting from Photoshop, you always have a few ways to do anything. The way I prefer is to select the top layer in the Layers palette, hold down the Alt (PC) / Option (Mac) key and select the menu Layers > Merge Visible. Right-click this new layer and choose Convert to Smart Object. Then it's Filter > Nik Software > Silver Efex Pro.

70

Learn presets & go beyond them

1 Display presets using this button.

Like Lightroom, Silver Efex Pro offers presets—quick recipes that give a picture a certain look and feel. But SEP's tightly defined role means there's not so much risk of presets getting in the way of your learning how to use the program properly.

You can display (or hide) the list of presets by clicking a button in the top left of the SEP window. Notice how the presets are broken down into categories with names like Modern, Classic, and Vintage that give a good idea of the result. Each preset also has a decent-sized thumbnail, so you can very quickly run your eye down the column, click one, and then another.

It's important to notice how applying some presets can affect picture characteristics that you may not want to change. For example, you may really like how a preset adds graininess, a sepia tone, and a fancy border, but overall brightness goes completely wrong.

There's no need to worry though. Instead, it's a good sign it's time to settle for what you like about the preset's output. Move over to the right-hand side where SEP lets you fine-tune the results. In this example, one might go to Global Adjustments and reset Brightness to 0%.

In some cases, that may be all you want to do to the picture, while some other times the preset may not need adjusting at all.

So this is the overall workflow: Launch SEP, try out presets, then fine tune in the right hand side. All you now need to do is click the OK button in the

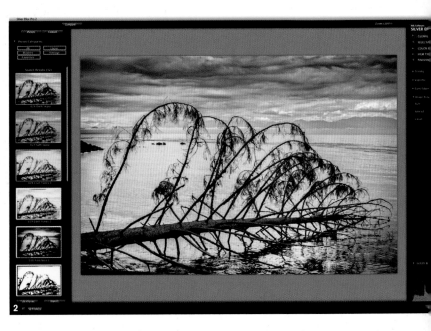

bottom-right corner. SEP closes, applies the treatment to the photo, and returns you to Lightroom, Aperture, or Photoshop. Of course, that's far too easy, isn't it?

2 Down the left, each preview shows how the image would appear, and can then be fine tuned in the right-hand side.

71

Don't overlook the Color Filter panel

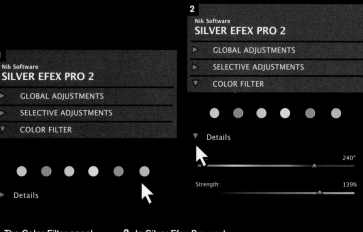

1 The Color Filter panel is based on the glass lens filters used by B&W film photographers.

2 In Silver Efex Pro, each control has several more detailed settings that can be displayed by clicking on this triangle.

Silver Efex Pro (SEP) presets are only a first step. Next, go to the right-hand side of the interface and go to Color Filter next, the middle panel.

Although it seems logical to work from the top down through all the various options, from Global Adjustments to Finishing Adjustments, the Color Filter panel is where you have control over how SEP manipulates the original's colors. Just like the color sliders in Lightroom's B&W panel, this is your big opportunity to put the original colors to work and help you pick out features in separate grayscale tones.

The panel's interface is based on the colored lens filters used by black-and-white film users, who find it very intuitive. But don't worry if you don't have that experience, because the principles are simple. Clicking red is like a red glass filter, and red glass allows through red light and tends to block blues and greens. This means skin tones are rendered lighter, for example, and blue skies are made a darker shade. It's the same idea for other filters, so clicking blue will lighten a sky and darken skin tones. If this isn't clear at first, just click each color in turn and evaluate its effect on a portrait and on a landscape photo.

To the left of the word Details is a small triangle. It is very easy to overlook at first, but it is important. Click it and SEP displays sliders which fine tune each color's behaviour. The Hue is an alternative to clicking the circular filters, while Strength slider lets you boost the effect of the current filter.

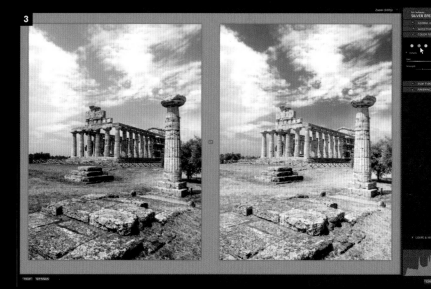

3 The choice of filter makes a huge difference to the balance of the picture. Here, the blue filter on the left results in a weak sky, while the red strengthens the sky and makes the grasses bright.

Before/After & History views

As you're working on a photograph, it is often helpful to keep a sense of whether you're really taking the picture in the right direction. We can all overdo a treatment, or sometimes we may need confirmation we've moved it forward. So one group of Silver Efex Pro tools you should use are its comparison and history features.

Silver Efex Pro's side-by-side view is similar to Lightroom's Before/After, and is activated by one of two small buttons at the top left of the SEP window. The Before side initially displays the picture as it appeared when you launched SEP.

There is also a History panel which records your activity during the current SEP session. You just click an item to restore those settings, or you can change what's shown in the side-by-side display's Before pane by moving the orange pointer to the step that you want as your benchmark.

1 Activate one of the side-by-side views.

2 You have the choice of a side-by-side layout or a horizontal view where Before is on the top and After is below.

3 Without splitting the screen, you can quickly switch the picture to its Before appearance. Just click and hold down the Compare button.

4 The History panel shows the work you've done.

5 The side-by-side view is a great way to evaluate your progress.

73

Gobal adjustments

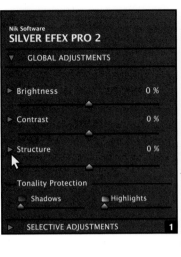

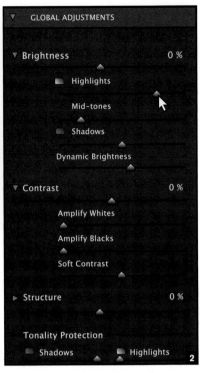

It's obvious that Silver Efex Pro's Global Adjustments panel is where you control the picture's overall qualities such as Brightness or Contrast sliders. What's less obvious is that their real value unfolds once you click each section's little "twirler" or triangle. The section expands and it reveals even more controls.

Under Brightness there are four additional sliders. Three are self-explanatory, so Highlights, Mid-tones, and Shadows allow separate control over the brightness of these specific tonal ranges.

The fourth, Dynamic Brightness, is one of the newer style "adaptive" adjustments which adapts its effect to different areas of the image. Broadly speaking, the algorithm targets blocks or ranges of similar tone, but protects smaller details or specific tonalities. By moving Dynamic Brightness to its left you can generally darken the image's overall appearance without wrecking the highlights. Similarly you can brighten the image while retaining key shadow detail.

Contrast also has three extra sliders that are revealed by the triangle. Amplify Whites boosts contrast in brighter parts of the picture, while Amplify Blacks targets the darker areas. Again these are adaptive, so they change the contrast of larger areas of highlights or shadows without damaging bright or dark details.

The Soft Contrast slider is less harsh than the effect of traditional contrast and tries to introduce a moodier contrast. It seems to work best when dragged gently to its left, reducing contrast in the whole image but preserving the sharpness of edges.

We'll come to Structure next, but don't ignore the two sliders in Tonality Protection. They're designed to allow the picture to recover from using other sliders more aggressively. For instance, you might ramp up the contrast, but then use Tonality Protection's Shadows to recover detail in the near blacks or pull back the Highlights.

1 Each control can be fine-tuned with extra sliders, which you display by clicking the small triangle.

2 The additional Brightness sliders allow separate control over the highlights, mid-tones, and shadows.

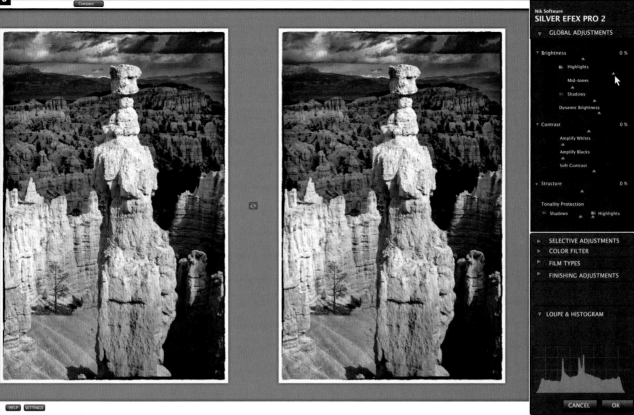

3 While overall adjustment should mainly be done before starting Silver Efex Pro, it allows you lots of control over brightness and contrast.

74

How to use Structure

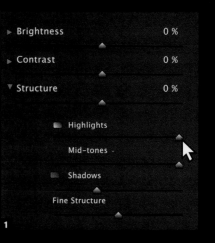

1 Silver Efex Pro's Structure adjustments can target different tonal ranges.

At first glance, Silver Efex Pro's "Structure" is the same kind of tool as Lightroom's Clarity or Aperture's Definition—a wide-area contrast adjustment that really adds punch. Image detail becomes much more obvious when the slider is dragged to the right, and less distinct when it's dragged to the left—but it has two key differences.

Firstly there's a little disclosure triangle, which reveals extra sliders allowing you to separately target the highlights, mid-tones, and shadow areas. The second difference is a slider called Fine Structure which targets much smaller detail—it works especially well on skin tones.

Dragging these sliders back and forth needs little explanation, but make sure to remember that Global Adjustments' Structure sliders are just that—global—and that SEP also offers Structure in its array of Selective Adjustments.

This means it's worth stopping to think about the picture's needs. Does it require more punch across its entire image area? Or do you only wish to emphasize certain features?

It is a key decision. While Global Adjustments' Structure can certainly boost a picture's impact, in many pictures there are parts of the frame which are softer or deliberately indistinct. Out-of-focus areas immediately spring to mind. You may not want to apply Structure and emphasize detail in these areas too. By their nature, out-of-focus areas shouldn't be made to compete for attention with important detail elsewhere in the picture.

Of course, very often the answer is a balance between the two—some Structure from Global Adjustments, but not so much that it unbalances the image, and Selective Adjustments' Structure to bring out the details that need extra emphasis.

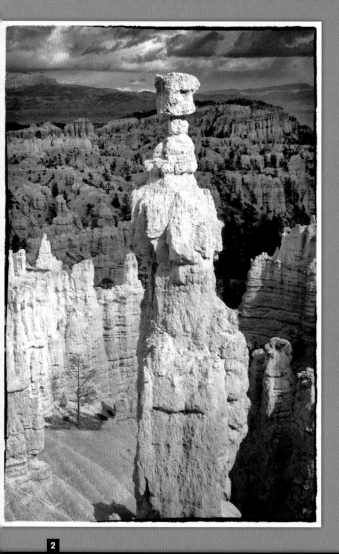

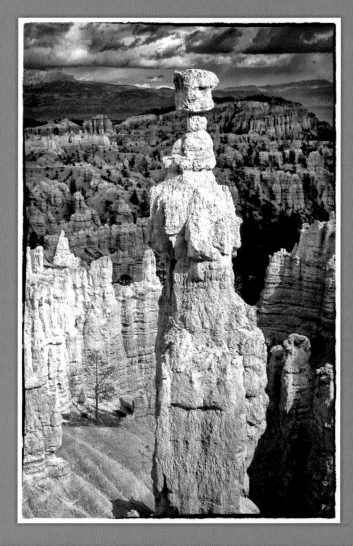

2 This picture has interesting detail in most areas of the frame, and this can be emphasized with the Structure sliders from Global Adjustments.

75

Selective adjustments

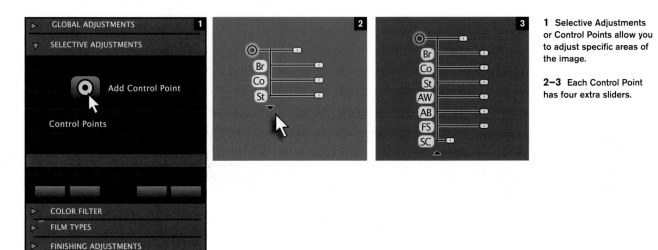

1 Selective Adjustments or Control Points allow you to adjust specific areas of the image.

2–3 Each Control Point has four extra sliders.

Dodging and burning, or fine tuning specific areas in a picture is really easy in Silver Efex Pro thanks to the "Control Points" feature that is found in Selective Adjustments. Click the button, click the picture, and drag the sliders that sprout from it. But while you might rush ahead and continue using them at this basic level, it is well worth starting off by learning a number of tricks of how Control Points work.

1 Initially, a Control Point has one unlabeled slider which sets its size, and three labelled Br, Co, and St for Brightness, Contrast, and Structure. Always click the little downward arrow so you have four more sliders—Amplify Whites, Amplify Blacks, Fine Structure, and one with the intriguing name of Selective Color.

2 Don't be afraid to add lots of extra Control Points. Just click the round button again and the new point is displayed with its sliders extended.

3 Reactivate other points by clicking them. You can then change the sliders, double-click one to reset it to 0, drag the point to a different position, or remove it with the Delete key.

4 To save time, duplicate an adjustment. While the a Duplicate button in the Selective Adjustments panel, the easiest way is to click a Control Point, copy it with Ctrl C (PC) / Cmd C (Mac) and immediate press Ctrl V (PC) / Cmd V (Mac). Then click the image where you want to apply the duplicate Control Point.

One other tip is especially helpful when you're reviewing your work. All those orange points can get in the way, so just move your cursor out of the image area and all the Control Points are temporarily hidden. You can see your picture again!

4 You can adjust several points simultaneously. Hold down Ctrl (PC) / Cmd (Mac), click each point, and you can then drag one slider and change all the selected Control Points at once. To combine several points together, there's a grouping button in the Selective Adjustments panel.

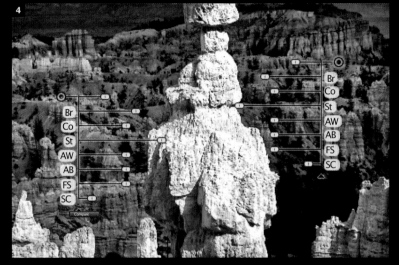

76

Add emphasis with control points

▼ Control Points		
		■
✓ Control Point 1	34%	■
✓ Control Point 2	20%	
✓ Control Point 3	20%	■
✓ Control Point 4	20%	
✓ Control Point 5	20%	■
✓ Control Point 6	30%	
✓ Control Point 7	20%	■
✓ Control Point 8	20%	
✓ Control Point 9	30%	■

When you start adding Control Points, try to think through what you want the picture to say. This should then determine how many Control Points you add, and what each one does.

Generally speaking, brightening or adding Structure will draw attention to part of the image, while darkening it and lowering its contrast will subdue its role in the composition. These broad concepts of dodging and burning are shown in the main picture here. My thoughts about the picture's original appearance led me to add three groups of Control Points:

1. Those placed in the sky have small negative Brightness adjustment because I felt those brighter areas needed to be less obvious—and other areas more obvious, relatively speaking.

2. A series of points is positioned along the buildings. These include Structure, Contrast, and some extra Brightness adjustments because I want the buildings to stand out more.

3. Other Control Points are scattered around the river, brightening some spots and darkening others, with the goal again being to change the emphasis of the picture.

Think back to how one should try to balance Global Adjustments with Selective Adjustments and the canyon picture on the previous pages. It was full

of detail in the cloud and the landscape, which was emphasized by the global Structure adjustment. But with this riverside picture, global application of Structure would have ruined the soft flowing appearance of the clouds and river. This scene needed specific or local adjustments, so Control Points apply Structure adjustments to make the buildings a relatively stronger element in the composition. With a little experience, the thinking and planning becomes almost instinctive.

1–2 Ctrl A (PC) / Cmd A (Mac) displays all the Control Points.

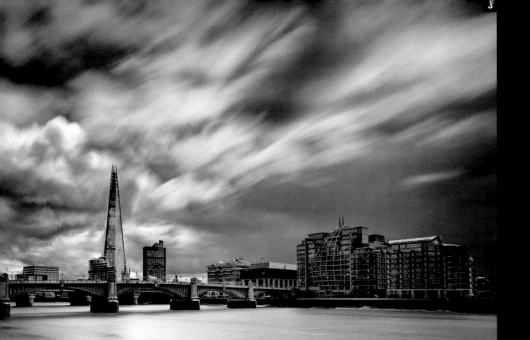

3–4 Control Points are an intuitive way to emphasize some parts of the image like the buildings, and tone down other areas like the sky.

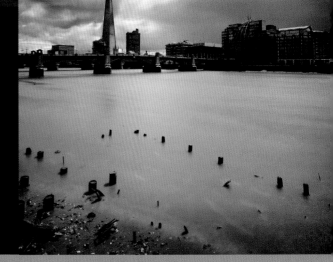

77

Control points block their neighbors

Two other characteristics of Control Points are really worth keeping in mind. Firstly, Control Points aren't simply circular adjustments, but have a kind of built-in intelligence. And second, each point controls its own area and usually resists its neighbors.

What do I mean by "intelligence"? Well, although the Control Point does have a size slider to define a circular target area, it's more important to consider where the point is placed. This is because the software assesses the area where the point is located and examines neighboring pixels' characteristics, textures and colors. SEP then uses this information to build a selection and target its adjustment on the selected feature.

This means you decide which feature you want to adjust, and position the Control Point directly on it.

In this case notice how I placed the Structure adjustments on the buildings. SEP detected the pattern of windows and columns, and continued applying Structure until it met different textures in the sky and the river. Similarly, the Brightness points which I placed on the sky selected and darkened the clouds but didn't touch the buildings. It means you don't have to learn about masking and a range of other Photoshop techniques.

As well as this intelligent selection and targeting, each Control Point tries to intelligently control its own territory. This is most valuable when a Selective Adjustment's effect spreads outside the specific area you want to adjust, often when the feature's edges aren't clearly defined.

On these occasions the software needs a bit more human guidance, so place an extra control point in the area you want to protect. You don't even need to drag any of its sliders—simply use this point to block other Control Points.

Now that you know how to make local adjustments, and how to target their effect, that's most of what you really need to know about Control Points. As so often with digital photography, it's now a matter of lots of improvising from the same small bag of tricks.

1 The Control Point on the buildings adds Brightness, Contrast and Structure, while its neighbor darkens the sky. Each targets the area where it was placed, and blocks its neighbor's effect.

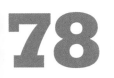

78

Doubling up control points

1–2 Three complementary Control Points—all with Structure adjustments— help Silver Efex Pro extend the target area of the adjustment.

In the previous tip, we saw how a Control Point can stand its ground and prevent the effect of other Selective Adjustments from spilling over. But if you were reading carefully you may have noticed that I said a Control Point "usually resists its neighbors." That "usually" is because nearby Control Points can also work together.

The trick is to add neighboring Control Points which have the same or complementary adjustments. For example, place two Control Points with +100% Structure onto the same feature and the Structure adjustment appears to be even stronger.

You are not actually getting a cumulative effect greater than 100%. Instead, what's happening is that the extra Control Points help SEP define the selection more precisely, and the area where the adjustment has a 100% effect is being extended.

So, as well as using one Control Point to block its neighbors, remember you can also use a Control Point to enlarge and intensify the area where the adjustment is applied.

79

Keep some features in their original color

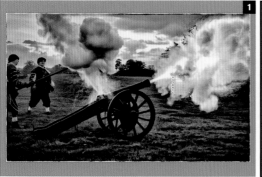

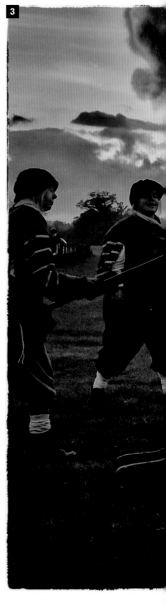

Until the mid-20th century, it was common to color prints by hand. This skill was largely forgotten once color negative film became widely available, but it was still a fun way to give an interesting finishing touch to a black-and-white print. It's well worth trying in Silver Efex Pro, and that's where you use the last of the Control Points, SC—Selective Color.

This Selective Color slider simply adds the original color back to the picture. Just like using any other slider, identify the feature you want to colorize, place a Control Point on it, and drag the SC slider to the right.

Selective Color runs from 0% to 100% which is when all the original color—only the color, not the color picture itself—will be restored. At high percentages it can look rather crude, and usually only a little color is enough to provide an intriguing twist on B&W.

Keep in mind those ideas about Control Points having "intelligence" and "territory." If you apply Selective Color to a feature, SEP will do its very best to detect its edge and to target the colorization. But there's a fair chance that some residual color will also be restored to the surrounding area. Get around this by adding extra Control Points which encircle the face. Each additional point takes control of its own area and blocks off the Selective Color adjustment.

Whenever you're working with Control Points, also keep thinking about their built-in intelligence and protecting territory, or using one Control Point to block off others.

1–2 The Selective Color slider allows you to restore the original color.

3 The final image includes
Selective Adjustments, plus
Toning and Borders from
Finishing Adjustments.

80

Mimic film grain

1 At lower values the Grain per Pixel slider produces more obvious grain.

A lot of admirers of black-and-white photography mention its gritty appearance as one of its attractions. If that's your thing, you'll be glad to know that Silver Efex Pro offers one of the best ways to achieve it.

Apart from liking the grainy look, one reason for adding grain is when you're producing a set of B&W prints from a mixture of photos shot on film and others taken digitally. Alternatively, the pictures may come from a variety of digital cameras and you might wish to make look them more consistent. Putting detail in blown highlights is another reason.

SEP's Film Types panel starts with a drop-down box listing some well-known films whose graininess and other typical characteristics are imitated. Pick the one you want, or just try different ones until one looks right to you.

When adding grain, it's a great idea to zoom in on the picture. At 100%, you get a much better idea of its characteristics, and you'll notice that the randomness and clumpy distribution is surprisingly impressive.

Notice too that Grain has one of those little triangles. As usual, click it and open it up. In this case it reveals two additional sliders.

The first, Grain per Pixel, works just as you would expect if you think of it in terms of real world grains. Push the slider to its right and more grains per pixel means it simulates very fine-grained film— so the grain is less obvious. Pushed to the left means fewer grains per pixel and bigger lumps.

The second extra slider, Soft to Hard, is about the edges of the grain. Push the slider to the right and the grain is better defined, as if a film has been developed to sharpen grain appearance. Moving the slider to its left softens the granularity, again just as you can do in the darkroom. Sharper or less defined grains will suit different types of picture.

Just be aware that SEP's film types are only imitations. Real film grain is influenced by factors other than film stock, for instance the enlarger lens or developing processes. Also, not all B&W film produces lots of grain—some are ultra smooth—so don't feel obliged to use Film Types panel.

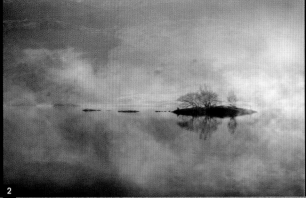

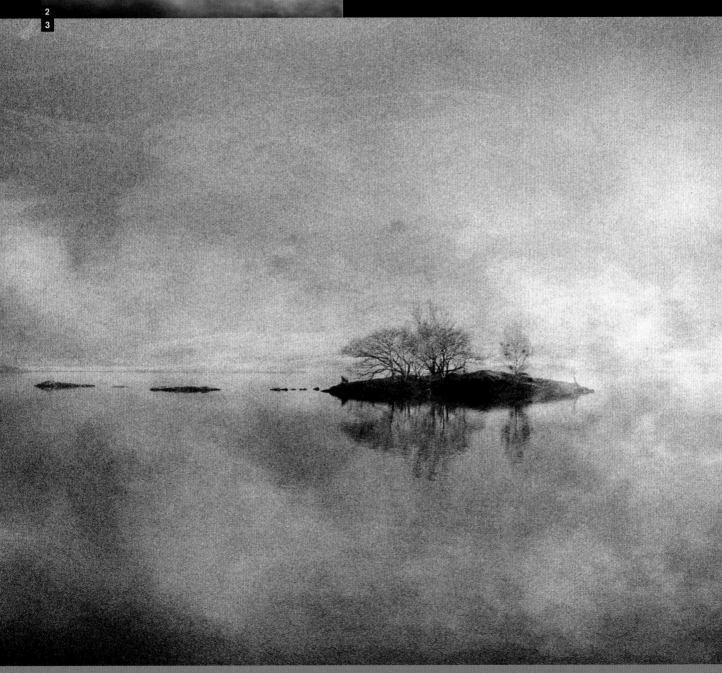

2–3 Grain can be used to imitate film or produce a Pointillist-style image.

81

Add a tone

1 Toning's extra sliders let you define the color of the shadows and highlights.

By the time you reach Finishing Adjustments, the fifth panel in Silver Efex Pro's right-hand side, everything else about the picture should be more or less locked down. These tone and border effects are finishing touches, letting you imply emotions and physical sensations such as coldness with a hint of blue or warmth with a bit of sepia, or adding a certain style. You certainly don't want to overwhelm the picture, however.

The Tone control has a drop down list of swatches. One nice detail is that you don't need to click them—just roll the cursor over the swatch and the tone is previewed live. Click the swatch to apply it.

By now, you should need no more reminders that if you want more control, you look for the triangle to the left of the word Toning. Here the more important extra sliders are in two pairs, one pair labelled "Silver" and the other called "Paper." The Silver sliders set the color of the grays and blacks in the image, as if you're applying a darkroom toning solution which works from the shadows. The Paper sliders control the color applied in the highlights. Each pair consists of Hue to control the color and a percentage slider to control it strength.

It's usually enough to play with the Silver and the Paper sliders on their own, but you can also control how much of the image is affected by each of the pairs. That's the Balance slider. Moved to its left, the Silver or gray tones extend more into the highlights. Moved to the right, Balance makes the Paper or highlight tone.

Because Silver Toning and Paper Toning both control the strength of color, you may not need to use the overall Strength slider. But don't forget it. Maybe it's better used after the other sliders, simply to pull back the Silver and Paper colors. After all, the eye can detect such a slight color cast. Think of Strength as an inverted Subtlety slider—the lower its percentage value, the more your toning adjustment will add to the picture.

2 FINISHING ADJUSTMENTS

Toning

Vignette Neutral 1

Burn Ed Split Toners 2

Image B 3

Size Selenium 4

Spread 5

Clean 6

 Blue Toner 7
 8
 9

 Cyanotype 10
 11
 12

 Coffee 13
 14
 15

 Copper Toner 16
 17
 18

 Sepia 19
 20
 21

 Ambrotype 22
 23
 24

 Custom 25

2 Toning's drop-down list
provides a wide range of
colored tones. Just roll the
cursor over the swatch and
the tone is previewed live.

3 Just a hint of tone can be
enough to set the mood.

82

Vignette & burn the edges

Two of Finishing Adjustments controls, Vignette and Burn Edges, should usually be considered together. They often do the same work, darkening the edges and corners of a picture to nudge attention toward your subject, or lightening the corners might imply a more romantic or dreamy mood or give an "old world" feel.

Like other adjustments, Vignette has extra sliders. Amount is the key since its values can be positive or negative, brighter or darker. Dragged to the right and the corners are brightened, to the left and they are darkened.

The Circle-Rectangle slider then allows you to shape the vignetting, while Size determines how much of the picture is affected. You just need to experiment.

One especially useful feature is the Place Center button. Click this, then click the area of the image where the vignette should be centered. This gives you a lot of control over the final result.

Burn Edges is very similar, though it focuses on the edges. Its extra sliders allow you to target each side individually, so for example you might darken one side which is so bright the composition seems unbalanced.

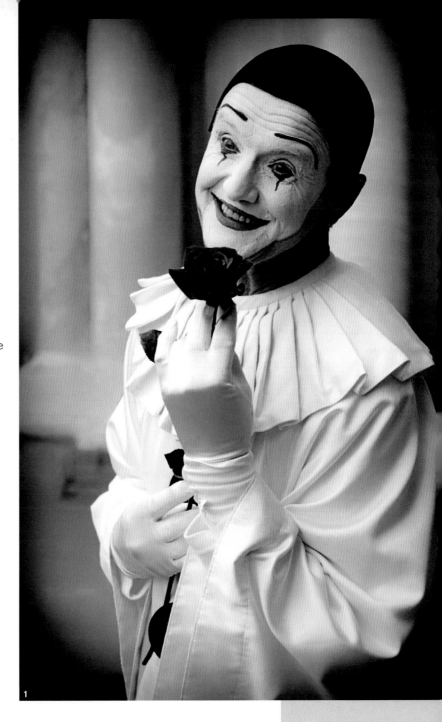

1

1 Dark-cornered vignettes and edge burning give a more foreboding mood.

2 When set to brighten the corners, vignettes can give a light or dreamy mood to a picture.

3 The Vignette control offers standard effects and extra sliders.

4 The Place Center button controls where the vignette should be centered.

▼ FINISHING ADJUSTMENTS

▶ Toning

▼ Vignette Custom

Amount

 Off
 Lens Falloff 1
Circle Lens Falloff 2
 Lens Falloff 3
Size White Frame 1
 White Frame 2
 Black Frame 1
 Black Frame 2
▶ Burn Edges Custom

▶ Image Borders Off

3

4 FINISHING ADJUSTMENTS

▶ Toning

▼ Vignette Black Frame 1

Amount −25%

Circle Rectangle

Size 33%

Place Center

83

Adding stylized borders

Silver Efex Pro makes it extremely simple to add a range of simple or decorative borders to your pictures. Again it's the familiar idea of a drop-down box and extra hidden sliders, so you move the cursor through the various types of border, click one, and then fine tune it with the Size, Spread, and Clean-Rough sliders.

Two points are worth emphasizing. The Clean-Rough slider is handy because most of the borders are decorative and designed to look like torn paper edges, or like the borders created by larger format film negatives or by customized darkroom equipment.

The other detail is the Vary Border button. This takes the current border's parameters and redraws them slightly differently.

Its main value is when want roughly the same border on a series of pictures, but you don't want all their borders to be absolutely identical. What you do is apply the Type 9 border, for example, to a picture and then click Vary Border. You've given the pictures a consistent looking border but introduced a bit of almost-natural variation.

FINISHING ADJUSTMENTS

▶ Toning

▶ Vignette — Off

▶ Burn Edges — Off

▼ Image Borders — Type

Size	Off
Spread	Type 1
Clean	Type 2
	Type 3
	Type 4
3659	Type 5
	Type 6
	Type 7
	Type 8
	Type 9
	Type 10
	Type 11
	Type 12
	Type 13
	Type 14

1

FINISHING ADJUSTMENTS

▶ Toning

▶ Vignette — Off

▶ Burn Edges — Off

▼ Image Borders — Type 9

Size	−59 %
Spread	71 %
Clean	Rough
3659	Vary Border

2

1 Roll the cursor over the choices and Silver Efex Pro previews the fancy border's effect.

2 Use the Vary Border button to add important variation between pictures with similar borders.

3 Decorative borders and toning can give a distinctive look to a black-and-white image.

84

Save your own presets

Some people don't mind spending time repeating work from scratch, and are happy being unable to quickly copy a look to other images. Others appreciate that presets can save you time and help you be more consistent. So once you have spent time working on a picture and think you may want to reuse that treatment, save your own presets.

If the presets aren't visible, click the Show Preset Browser button at the top left. Then at the bottom left, click Add Preset, enter a name and you're done.

One small bit of advice is to choose the preset's name to indicate aspects that aren't immediately obvious in preview browser. For example, a name such as "Warm Sepia Cold Blue Grainy Border 9" includes tones which are perfectly visible in the preview, so the shorter "Grainy Border 9" tells you all you need to know. A picture tells a thousand words!

1–3 Saving your own presets saves you time in future and lets you produce a consistent series of images.

85

Copying from one image to another

If you want to apply one image's Silver Efex Pro treatment to another picture, it's possible that you may have had the foresight to save it as a custom preset earlier. In that event, you would then open the other picture, and apply your preset.

But as we saw earlier, if you own Photoshop, the ideal way to launch Silver Efex Pro is by applying it to a "smart object" layer. The B&W effect is then applied as a "smart filter." One big benefit is that you can fine-tune the SEP settings in later Photoshop sessions. The other big advantage is you can copy your SEP treatment to other pictures.

As a starting point, let's assume you have already processed one picture through Photoshop and SEP using the smart object method. You have already applied Silver Efex Pro adjustments to it, and you want to apply the identical treatment to another picture which you also opened as a smart object.

In Photoshop arrange the pictures so both are shown on screen. Window > Arrange Horizontally / Vertically is the easiest way.

Activate the picture which already has the SEP adjustments, and display the Layers palette (F7 is the keyboard shortcut). Notice how the picture layer has the smart object symbol in the bottom right of the thumbnail, and how it also has a sub-layer containing the Smart Filter. You should see it's the Silver Efex Pro smart filter.

All you now need to do is drag this smart filter from the Layers palette and drop it directly onto the other picture. Photoshop will then apply the SEP treatment to the other picture. It's that straightforward, and it saves lots of time.

1 A smart object has its Silver Efex Pro adjustments applied as a "smart filter."

2 Arrange the images side by side and drag the smart filter from one picture to another.

3 Smart objects make it easy to reproduce the Silver Efex Pro treatment and use it on other pictures.

86

Pick your paper

1

For many years, making a print was almost the only way a black-and-white photograph could be shared with the world. It's no longer so simple—not after a decade of pictures being shared online or by email, and now on tablets and phones too. But while we are no longer so obliged to make prints, we still appreciate a well-made print for its physical quality and appreciate when some thought has gone into a careful choice of paper.

A lot of different papers are marketed at photographers, brands come and go, and product availability varies in different countries. So it's difficult to recommend specific papers or suppliers, but one can do better than saying it's a case of getting the quality you pay for. There is guidance one can give.

First, though it's great to shop online, take every opportunity to choose papers with your own eyes and to touch them before you buy. Photo trade shows are great for seeing and feeling the different types of paper, or your local photo store may have swatches available. Paper vendors often sell sample packs with an assortment of their photo papers.

Personal preference plays a very big role. You need to see a paper's high gloss, lustre or matte appearance before you can you decide that you like how it looks. Many photo papers are resin-coated and have a shiny-smooth plastic appearance. It's only when you see it with your own eyes that you know that one of these papers may be value for money for the fun prints you want to make. But for

another set of prints the choice of paper may be totally unsuitable.

Looking and touching is just as important with more expensive fibre-based papers. Their extra weight and more traditional texture make the print feel like a higher-quality product. When you're choosing between these papers, look closely at their surface textures. They don't all look the same, and while one paper's stippling may be unattractive there will be another whose surface looks more natural. Another factor is the paper's base tone which is not always pure white. A very slightly warm white may suit some types of photos, but this is only obvious when you examine the paper yourself.

INNOVA

DIGITAL FINE ART PAPER for
PHOTOGRAPHY and ART

FibaPrint® Range

Fine Art Range

Canvas Range

Photo Range

Fine Art & Photo Trial Pack

1 × FibaPrint® White Matte 280gsm (IFA39)
1 × FibaPrint® White Gloss 300gsm (IFA09)
1 × FibaPrint® Warm Tone Gloss 300gsm (IFA19)
1 × FibaPrint® Semi-Matte 300gsm (IFA29)
1 × FibaPrint® Ultra Smooth Gloss 285gsm (IFA49) NEW!
1 × Soft White Cotton 280gsm (IFA15)
1 × Smooth Cotton (High White) 315gsm (IFA14)
1 × Smooth Cotton (Natural White) 315gsm (IFA11)
1 × Soft Textured 315gsm (IFA12)
1 × Cold Press Rough Textured 315gsm (IFA13)
1 × Matt Canvas Polycotton 380gsm (MC12)
1 × Glossy Canvas Polycotton 390gsm (CG15)

2

87

Don't limit your choice of paper

When you're choosing photo paper, you won't go too far wrong with products from your printer's manufacturer. That said, it is also a mistake to limit yourself to using only those papers—specialist third-party paper suppliers offer a great variety of high-quality alternatives.

Printer manufacturers like Epson sell a wide variety of photo papers, and to some extent their business model is to hold down hardware prices and make their money on the consumables—the papers and ink cartridges. One advantage of their papers is widespread availability. They cover the cheap and cheerful end, and also produce the more expensive fiber-based papers. Consistent quality results from big production volumes, and there must be some benefit from being tested and matched to the manufacturer's printers and their inks. Using these papers means you can simply select Managed by Printer in Lightroom's Print workspace or in Photoshop and not bother about printer profiles. In Epson's case, their more modern printers also offer what they call an Advanced Black-and-White Mode, which can be useful.

Specialist or third-party paper suppliers range from internationally available brands like Hahnemuhle, to companies like Red River or Permajet who mainly operate in their domestic markets. Product ranges and availability are constantly changing, and in some cases exactly the same paper may be sold under more than one label. These third-party vendors tend to target the high end of the market.

In general, better papers tend to share certain characteristics. They are often fiber-based, and while not being as much like traditional darkroom prints as their makers often claim, these papers do look and feel good. Partly that's a result of their physical weight, so look for weights of around 250 gsm (grams per square meter) or above. Also look out for the lack of optical whitening agents and the paper being acid-free.

Whether you use the printer manufacturer's own paper or third-party products, looks out for these papers' physical qualities because they will usually help make the most of your print.

1

2

1 Highly textured papers aren't right for every subject, but can be perfect for some.

2 A selection of glossy and matte papers—notice how their surfaces and base tones differ.

88

Make sure you get paper profiles

One other factor in your choice of paper should be whether it is supported by paper profiles.

Variously called "paper profiles," "printer profiles," or "ICC profiles," these small files record how a given paper performs on that specific type of printer. Essentially, they tell your PC or Mac how it should translate colors into instructions for the printer.

Epson and other printer manufacturers support their own papers through the printer driver. After you install a printer, the computer's printing dialog box will display options for its manufacturers' papers. This is printing "Managed by Printer."

Here though we are taking the other route— using profiles. Specialist suppliers as well companies like Epson usually offer ICC profiles to support their papers. So go to their web sites and look around.

You need a very specific profile—the paper you want, on your printer model, and on your operating system. What's more, you should expect to find this profile. If you can't do so, it's usually not a good sign and that paper may be more trouble than it's worth.

This is where the specialist paper suppliers are usually very good. If they are worth their salt they will offer good profiles to support their products. You may just have missed something on their web site, be using a new printer which they haven't yet profiled or a printer that is older than the models they anticipated people using with their paper. You can always contact them and ask, and they often make a new profile. In some cases, you find that a paper supplier builds custom profiles that are specific to your very own printer as a free service in support of their papers.

One other possibility is to pay a color printing consultant to prepare a profile for the paper and your printer. But don't be tempted to try to profile papers yourself—the kit is expensive and the learning curve is long.

In the end, you can almost always rely on the paper manufacturer supplying good profiles. If you can't obtain a profile for a particular paper, just choose another paper.

1 Any paper vendor will list profiles by specific printer models.

2 This paper supplier's profiles can all be downloaded as a zip file.

89

How to load paper profiles

Once you've got some profiles for the papers you plan to use, the next thing to do is install them. In some ways this is easier than it used to be, but it does vary depending on whether you are using a Mac or Windows computer.

After downloading the zip file containing the profiles, unzip it and put the *.icc files in a temporary folder in a convenient place—on your Windows or Mac desktop, for example. Afterwards, delete the folder.

Installation is easy on recent versions of Windows. Just right click each *.icc file and choose Install Profile, usually the first item in the context menu.

On a Mac it's a little bit more difficult. You have to use Finder to copy the *.icc files to the Profiles folder, which should be easy enough. The trouble is that this folder can be in a couple of places—and it may be invisible too!

First decide if you want all users of the Mac to have access to the profiles. If so, log onto the computer as an admin user. You then copy the *.icc files to the global Profiles folder:

Mac HD > Library > Colorsync > Profiles

Alternatively, if you want to keep the profiles to yourself, copy the *.icc files to the user Profiles folder:

[username] > Library > Colorsync > Profiles

Somewhat inconveniently, in Mac OSX Lion the Library folder was made invisible. While there are ways to make it permanently visible, they involve using a feature called Terminal which isn't for most people.

Instead, the easier way to get to the Library folder is in Finder. Go to Finder's Go menu and hold down the Alt/Option key. You'll notice that an extra item appears—Library. Select this and Finder opens the Library folder. You can now go to Colorsync, then Profiles, put the *.icc files in there and you're done.

1 In Windows, installing *.icc profiles is easy, with just a couple of clicks.

2–6 Apple has made it a bit more difficult with recent updates—the goal is to get the profiles dropped into the Colorsync Profiles folder, which can be accessed by the Go menu in Finder.

90

Calibrate your monitor

As you begin to get more serious about your printing, you may soon hear about the need for color management. While this topic can lure you into costly and technically challenging depths, you can get real benefits from just dipping your toe in its waters. If you do no other color management, you should still calibrate your monitor.

The underlying problem is that your PC or Mac needs an accurate idea of what you are seeing. Is your monitor a bit magenta, slightly green, or blueish, and how contrasty is it? Calibrating the screen tells the computer exactly what you are seeing, and it can then match this monitor profile to the paper profile and send the right numbers to the printer.

To calibrate your screen you need a colorimeter, a hardware device that attaches to the computer's USB port. Popular models like the ColorMunki or Spyder are placed on the monitor, and on-screen instructions lead you through the procedure. A series of color charts is measured by the device, and finally its software saves the profile in the correct place for Windows or Mac. These devices are designed for novice users, so they even remind you when you haven't calibrated your screen for a while.

The benefits should be immediate. Your prints should look a lot closer to what you see on screen, so there will be less trial and error and you'll have to make fewer test prints. Printing should be less costly and less frustrating.

1 If you don't go any further into color management, at least calibrate your monitor.

91

Print with your profiles

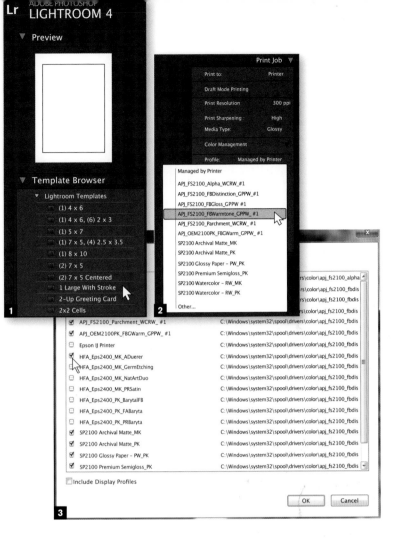

Once you've gone to the trouble of getting your screen calibrated and you have paper profiles loaded into your Mac or PC, you want to be sure your computer uses them. So let's look at a very basic printing task and see where you apply those profiles.

Nowadays, plenty of the work is done for you and you shouldn't have to think about the monitor profile. Every time your computer restarts it will load the monitor profile automatically.

So that we have a common starting point, in Lightroom's Library select a single picture and go to the Print workspace. In the left hand side's Template Browser choose "1 Large with Stroke."

For this example, go straight to the Print Job panel and don't bother with the other panels in the right-hand side. If you want to explore them later, you'll find that in the Image Settings panel you can switch off the border stroke, for instance. Under Layout you can do things like adjust the margins, while under Page are options for adding copyright watermarks or text. But leave these panels alone for now.

In the Print Job panel make sure that Print To is set to Printer, that Draft Mode is unticked, leave Print Resolution at 300ppi. We'll soon look at Print Sharpening, so leave it ticked and set to Standard for now, and choose Glossy or Matte as appropriate for your paper.

The Color Management step is the key. Open up this section by clicking the dark gray triangle, and click the Profile drop-down box.

When you are using this for the first time the choices should be "Managed by Printer" and "Other...." Choose Other and Lightroom lists the profiles installed on your computer. We're only interested in paper/printer profiles, so Display Profiles should be unticked. Then run through the list ticking the profiles for the papers you intend to use, and click OK.

From now on, every time you go to Print, you just choose your paper from the Profile drop-down box, and hit the Print button.

1 Lightroom's templates are handy ways to save print layouts that you often use.

2 Choose your paper from the Profile drop-down box, or click "Other" to add other profiles to the list.

3 The Choose Profiles dialog box lists other paper profiles on your computer. Here there are some new Hahnemuhle profiles that you can add to Lightroom's drop-down list.

92

Avoid double color management

Before you send a picture to the printer, it is common sense to set up the correct size of paper in the Print dialog box. But there's one other important detail that is easy to overlook—that the printer's color management is not fighting against the computer's color management. Watch out for "double color management."

Broadly speaking, every inkjet printer has its own built-in system and utilities to manage color and generally enhance the print—sharpening it, for instance. For most people this means they can just send documents to the printer with no further fuss, and by default the printer's color management is switched on. But the problem occurs with more demanding tasks such as printing photos from specialist applications like Lightroom or Photoshop when the computer is also managing color and using monitor and paper profiles to adjust the instructions it sends to the printer. If both systems are trying to manage color the print's colors are unpredictable—typically greens and magentas.

It is easy to resolve: Before you send the final instruction to print, check that the printer's color management is switched off. From Lightroom you can get to the printer's setup via the Print Settings (Mac) or Page Setup (PC) button, or when you hit Print.

The important point here is to say that you need to remember to switch off the printer's color management. It's less easy to show how you do that with your printer and your computer's operating system. Printers from different manufacturers have different dialog boxes, using slightly different terms, and a further complication is that Apple have been changing how it handles photo color. So you may have to review your printer's manual, or Google "disable color management Epson printer Mac Lion" (for example) and you will find someone has documented the exact steps.

1 When a paper profile is selected on Mac OSX Lion in Lightroom, there's no need to disable Epson's color management—Lightroom automatically overrides it.

1

Print Setup

Printer

Name: EPSON Stylus Photo 2100 ▼ | Properties...

Status: Ready
Type: EPSON Stylus Photo
Where: USB001
Comment:

Paper

Size: A4 210x297 mm
Source: Sheet Feeder

Help | Network...

2

EPSON Stylus Photo 2100 Properties

🖎 Main | 🖉 Paper | ⊕ Layout | 🛠 Utility

A4 210 x 297 mm

Media Type
Archival Matte Paper ▼

Color
◉ Color ○ Black

Mode

EPSON
○ Automatic
○ PhotoEnhance
◉ Custom

Photo – 720dpi
No Color Adjustme
MicroWeave: On
High Speed: On

EPSON
Version 5.92

3

Advanced

🖎 **Media Type**
Archival Matte Paper ▼

Color
◉ Color
○ Black

📷 **Color Management**
○ Color Controls
○ PhotoEnhance4
◉ No Color Adjustment
○ sRGB
○ ICM

📷 **Print Quality** Photo–720dpi ▼

🖌 ☑ MicroWeave

🖎 ☑ High Speed

🖎 ☐ Flip Horizontal

🖎 ☑ Finest Detaill

🖎 ☑ Edge Smoothing

Paper Config | Save Settings... | OK | Cancel | Help

4

2–4 With Epson printers and Windows, you switch off printer color management by going to the Printer's Properties button, choosing Custom mode, and then disabling the automatic color correction option.

93

Print & evaluate

1–2 Use daylight to review fresh prints. Daylight-balanced lights and integrated stands are available too, in a wide range of shapes and sizes.

So you've gone to the effort of choosing a paper, calibrated your monitor not too long ago, you've told the computer to use the right paper profile, and have disabled the printer's color management. Everything should be right—the paper is loaded in the printer—and so you've hit the button.

Sometimes, the print looks just right, so allow it a few minutes to dry, handle it with care, and keep it away from dust or anything else that might settle on it. Then review it again once it's dry.

Often there is a gap between what you saw on screen and what's in your hands. This is not unexpected, even when you have taken care to follow the right steps. To some extent, with printing you have to recalibrate your own expectations—light reflected off ink on paper is fundamentally different from the light of pixels on a computer monitor.

While you can buy daylight-balanced lights designed for print evaluation, it's not too hard to go over to the window and assess the picture in good daylight. Is its brightness pleasing, and how about the contrast? Is there detail in the shadows, and no lumps of solid black? How about the highlights?

Also review the sharpness. Sharpening for print used to be a topic in its own right, but Lightroom has taken the best techniques and hidden them in choices of Standard, High, or Low. As with print color and brightness, sharpness on a screen is fundamentally different to ink on paper, and the only way you can evaluate it is by looking at the print itself.

But don't be discouraged if what you saw on screen may not look right on paper. Experts expect this, and what your preparation has achieved is to get you much closer to the right print the first time.

94

Reprint & reevaluate

By doing the bare minimum color management—calibrating your monitor and using paper profiles—if you're lucky your print may be perfect first time. If not, it shouldn't be too far wrong, and will probably only need tweaking, bumping up its brightness, or tailing off the contrast for instance. Instead of going back and revising the picture's adjustments, just do a quick fix in Lightroom's Print Job panel.

Black and white is mostly about brightness and contrast, so it's ideal that the Print Job panel has two corresponding sliders.

To use them, tick Print Adjustment and then drag the sliders in the directions you need—right to brighten or increase contrast, left to reduce them.

The idea is that these are quick-and-easy fixes, and there's little to be said about them other than recommending a little experimentation—one or two test prints—to establish the right settings for the specific paper you are using on your print. But they are usually all you need.

1 Lightroom's Print Job panel includes quick adjustments for brightness and contrast.

Save your settings

We just saw how it's perfectly normal to make fine tune Lightroom's Print settings for a paper / printer combination. These quick brightness and contrast adjustments in Print Adjustments will usually be more or less the same for every picture you print using that particular paper and printer. So before you move on, save your settings so you can reuse them.

Saving Print settings is easy. Just go to the Template Browser on the left-hand side, click the little + button, and type in a name that will mean something to you later.

It's worth remembering that a template stores all the settings from Print's right-hand side. That includes settings such as any border stroke, watermarks, how many pictures per page, and so on. But they also record your choice of paper with the associated paper profile and any Print Adjustments you make for it. So a name such as "Single image Epson Exhibition Fiber" can be helpful.

Next time you want to print on the same paper, click your template and its settings are applied to the print job.

It's not a bad idea to save a template for each paper you use. Once you've saved templates for your favorite papers, switching between them is such a trivial task and you're effectively free to treat choose the right paper for the job. That isn't to say you should spend money on lots of different papers. Master a few tried and tested ones—a high-gloss paper that suits color pictures, for example, or a

1

fiber-based paper for a black-and-white print. Just don't be afraid to try new products now and again.

Saving your own templates can then save you time and—equally important—should help improve the consistency and quality of your printing.

1 Save templates with the paper profiles and print adjustments for papers you often use, such as this mixture of Hahnemuhle, Epson, and Permanjet paper.

96

Consider soft proofing

It's not a big leap of the imagination to wonder if your computer could use paper profiles to generate previews showing how the picture will look when it's printed. Ink on paper isn't like light from a monitor, but the profile can still provide some indication of how the print will appear. You might then make some adjustments before printing. This area is known as soft proofing, and it's worth trying once you have nailed down how to use profiles. There's always a way to get closer to the right print, first time.

In Lightroom, soft proofing is available in the Develop module. To enable it, press the S key on your keyboard.

One thing that you should immediately notice is that Lightroom's background goes white. This is to help simulate how your picture will appear on white paper.

The other big change is at the top right of the screen where the Histogram becomes Soft Proofing. Here you need to go to the Profile drop down list and select the paper you plan to use. There should be a subtle change in your picture.

Next, tick the Simulate Paper and Ink check box and now the picture should change even more, depending on the characteristics of the paper profile you've applied. It will usually be less obvious with a profile for a high-gloss paper, more obvious with products like fiber-based papers, for example. You should also expect to see any off-white base tone too. When Simulate Paper and Ink is active, you are seeing an approximate but often useful preview of how the picture will print.

1 Choose the profile for the paper you wish to use.

ISO 100 17mm f / 22 30.0sec

Proof Settings :

Profile: HFA_Eps2400_MK_ADuerer

Intent Perceptual Relative

☑ Simulate Paper & ink

Basic ◀

3 Lightroom's soft proofing view shows the paper's base tone and other characteristics.

Proof Preview

Soft Proofing ▼ **3**

ISO 100 17mm f / 22 30.0sec

Proof Settings :

Profile: HFA_Eps2400_MK_ADuerer

Intent Perceptual Relative

☑ Simulate Paper & ink

Basic ◀
Tone Curve ◀
HSL / Color / B&W ◀
Split Toning ◀
Detail ◀
Lens Correction ◀
Effects ◀
Camera Calibration ◀

Previous Reset

97

Soft proof copies

If I know I'm going to have to adjust the image, I usually begin by switching to Before / After view with the keyboard shortcut Y. Make sure the Before side shows most recent edit state, so quickly drop out of soft proofing mode—the S key—and copy the After's values to Before. Then it's S again to go back into soft proofing.

The Before side is now the picture at its very best, at least on screen. You'll now adjust the After version, but thinking about changes to make it print as well as it can. It won't matter if those adjustments make it look lousy on screen—what comes off the printer is what counts. The Before side gives you a benchmark, so you can see there was interesting detail in the shadows or the highlights.

Always remember that light emitted from a monitor is different from light reflected off paper and ink. The soft proof preview is just a guide.

As soon as you make an adjustment, Lightroom asks you if you want to "create a virtual copy for soft proofing." Choose the default button Create Proof Copy.

It is important to understand what this does. There's still only one real file in your Finder/Explorer folders, but Lightroom now creates a second instance of your photo in its catalogue. One is the "master," but you are now working on a copy which is conveniently named after the paper profile. This virtual or proof copy is purely for printing on that paper. You can apply whatever adjustments the copy needs to make it print well, and without wrecking the adjustments you previously applied to the master version.

With black and white, the kinds of adjustment tend to be more limited than with color pictures. Generally, they are Basic panel adjustments like opening up the shadows or fine tuning the contrast.

After you adjust the picture so it prints well, just leave the virtual or proof copy in the catalog. As well as being available if you want to reprint the picture, it also gives you a good idea of the kind of adjustments to apply to the next picture that you find difficult to print on that paper.

Before: Master Photo

1

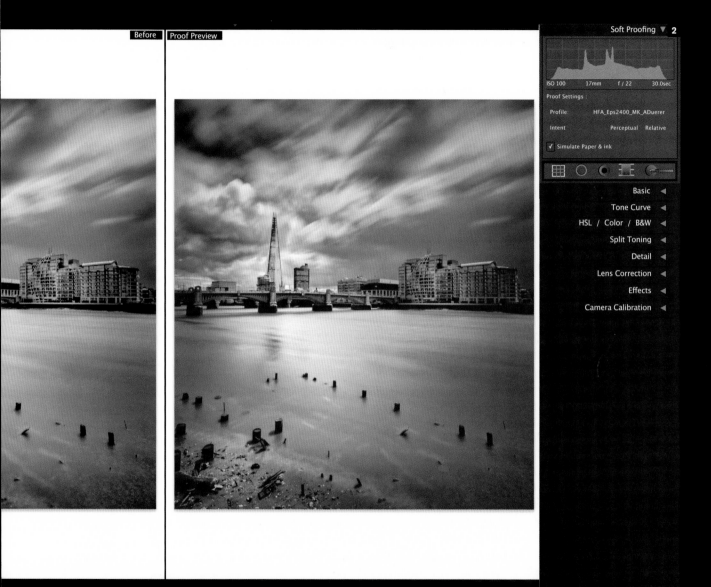

Before & After: Copy After's settings to Before

Before | Proof Preview

Soft Proofing ▼ **2**

ISO 100 17mm f / 22 30.0sec

Proof Settings :

Profile: HFA_Eps2400_MK_ADuerer

Intent Perceptual Relative

☑ Simulate Paper & ink

Basic ◄
Tone Curve ◄
HSL / Color / B&W ◄
Split Toning ◄
Detail ◄
Lens Correction ◄
Effects ◄
Camera Calibration ◄

Previous Reset

1 Make sure the Before side shows the latest version of the picture. Use the toolbar, Alt Ctrl Shift + Left Arrow (PC), or Option Cmd Shift + Left Arrow (Mac).

2 When you switch to Before / After view, soft proofing indicates that the print is going to look a lot softer and warmer on this paper than the picture appears on screen.

98

Other ways to get neutral B&W prints

1 Pure monochrome inks are less available now that printers include a third grayscale ink, but can't be beaten for print neutrality.

Using paper profiles isn't the only approach to getting high-quality black-and-white prints. Another approach is to replace your printer's ink cartridges with third-party inks. While only time will tell if this is an idea that has had its day, keep an eye out for these products—they can be very good indeed.

In the old days—well, ten years ago—inkjet printers usually had two grayscale ink cartridges. Used on their own, they could output perfectly neutral blacks and whites, but two inks were insufficiently for smooth-toned photographic printing. So the printer blended in some colored ink and sought to balance any color shifts by blending in other inks. It sounds like a kludge, and it was—color casts were almost unavoidable.

So a number of companies developed monochrome ink cartridges—Lyson, Marrutt, and Permajet, for example. These inksets were for commonly-used printers, Epson especially, and you simply pulled out the color cartridges and slotted in the replacements. You just need profiles, which the ink supplier provides, and are then good to go.

These monochrome cartridges consist of three to five grayscale inks. As a result, the neutrality of their black-and-white tones can be simply astonishing by comparison to photos printed using the printer manufacturer's color inks. The replacement set also includes three to four color cartridges, so you can add toning if you choose. A downside is if you want to make a color print. You'd either swap all the cartridges over, or buy a second printer.

However, printer manufacturers also saw the demand for neutral black and white and introduced printers with an extra grayscale cartridge, and today a printer with only two grayscale inks should be avoided for B&W. While third grayscale ink doesn't completely eliminate the neutrality problem, it's now good enough for most discerning black-and-white photographers.

Because today's printers are better at B&W, the specialist monochrome inksets are now more difficult to obtain. They are still available though, and they still produce outstanding results.

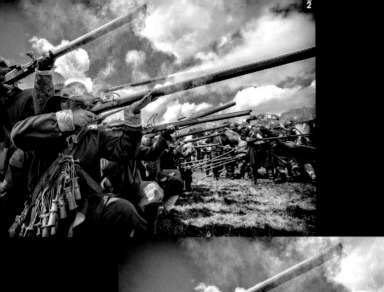

3

2–4 Your choice of ink can have a clear and visible impact on your final prints.

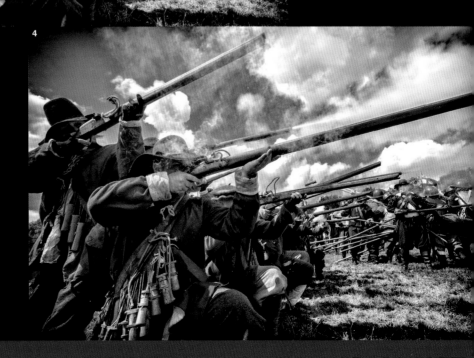

99

Advanced B&W mode

Printer manufacturers responded to
photographers wanting neutral black-and-white
prints in a number of ways. One was to add additional
grayscale ink cartridges, and another alternative is
available to those who own a recent Epson printer—
using the printer's Advanced Black and White
(ABW) mode. What is this, and why might you try it?

ABW mode is when you pick the "Managed by
Printer" color management option. So you don't
choose paper profiles from inside applications like
Lightroom or Photoshop, and you don't switch off
the printer's color management. Instead, you will be
selecting the paper and various options in the print
dialog box—and ABW is one of these options. The
printer's built-in software handles color management
and controls how it blends its grayscale inks—called
Black, Light Black, and Light Light Black in Epson's
Ultrachrome K3 inks—and how it adds colors to
improve tonality and balance the end result.

First, make sure your printer's specifications
include Advanced Black and White (ABW) mode.
It's available with most recent Epson photo printers.

In Lightroom, do your B&W adjustment work as
usual, and then go to the Print workspace. Here
everything is normal too, so you go down the panels
on the right, choosing the number of pictures per
page, borders, and any text you want to add. The big
difference is in Print Job and Color Management
where you choose "Managed by Printer."

When you're ready, press Print and you should
see the PC or Mac print dialog box. The next steps

1 Select Advanced Black
and White (ABW) mode by
choosing "Managed by
Printer," (rather than a
paper profile).

differ depending on the printer model, but are
usually quite similar.

From the Main tab, go to the Select Settings
drop-down box and choose Fine Art > Monochrome.
You will then see that Color Settings (a couple
of lines below) are now set to Advanced Black
and White.

Pick the paper type here too—your choices
are limited to Epson papers—and any other print
settings. You're then ready to print.

2 Access Advanced
Black and White mode by
selecting Monochrome
from the print dialog box's

100

Advanced B&W mode, part two

Maybe it's a pessimistic streak in me, but prints never seem to be perfect first time—or maybe the optimist believes you can always fine tune. If you prefer to use Epson printer's Advanced Black and White Mode, you can always make fine-tuning adjustments within the ABW settings.

While the standard settings should be good or Epson's papers, a downside of the Advanced Black and White Mode is that you're going to have to use trial and error if you wish to use third party papers. Click the Custom Settings button which lies to the right of Media Type in the print dialog box. This takes you down another level to where you can adjust the print's brightness and contrast, and even bump up its shadows.

Although the printer is mainly using its grayscale inks, it has all its color inks available and so here you can change its toning. It's worth considering why you would do this here. Sure, it is convenient if you're only thinking about printing, but prints are only one way we share pictures nowadays. Maybe it is better to do any toning in Lightroom? You can share the toned image by email, online, or print it to another printer in the future. Just think about it.

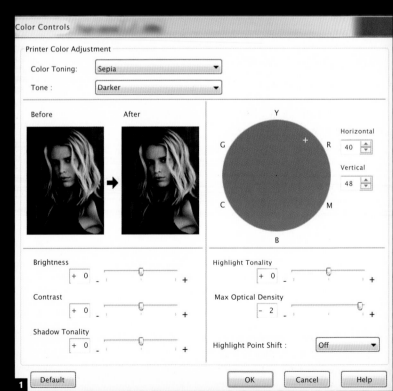

Save your settings

If you like to use your Epson printer's Advanced Black and White Mode, it makes sense to save custom settings.

Imagine you've made a print using ABW. The fiber based paper looks great, but it was third party so you had to tweak the brightness and contrast in ABW's custom settings. You added a cold blue tone too. You may have used up a few sheets of paper, ink, and time, but you've got there. Then a few months down the line you want to print it again.

But ABW keeps no record of what settings were applied to the picture, and in the meantime you've

Current Settings

Main
Media Type:
UltraSmooth Fine Art Paper
Print Quality Level: LEVEL 4 (Speed)
Print Quality: Superfine – 1440x720dpi
High Speed: On
Color: Advanced B&W Photo
Source: Manual–Rear
Centered: Off

Page Layout
Orientation: Portrait
Rotate 180°: Off Mirror Image: Off
Copies: 1
Size: A4210 x 297mm

Job Settings: Off

EPSON Stylus Pro 3880 Properties

Main Page Layout Utility

Select Setting: My 3rd party cold blue tone ▾ Save/Del...

Media Settings
Media Type: UltraSmooth Fine Art Paper ▾ Custom Settings...
Color : Advanced B&W Photo ▾ Matte Black Ink ▾
Print Quality : Speed ▾ Paper Config...
Mode : ◉ Automatic ○ Custom
 Neutral ▾

Paper Settings
Source : Manual– Rear ▾ Printable Area...
Size : A4 210 x 297mm ▾ User Defined...

Chapter_

Reference

Glossary

access time The speed at which the computer can communicate with its hard drive, measured for a desktop computer in milliseconds (ms).

active matrix display An lcd monitor using tiny transistors to generate the display. *See also* LCD (LIQUID CRYSTAL DISPLAY)

additive primary colors The three colors red, blue, and green, which can be combined to create any other color. When superimposed on each other they produce white. *See also* RGB *and* SUBTRACTIVE PRIMARY COLORS

algorithm Mathematical procedure that allows the step-by-step solution of a problem.

aliasing The jagged appearance of diagonal lines in an image, caused by the square shape of pixels.

alpha channel A grayscale version of an image that can be used in conjunction with the other three color channels, such as for creating a mask.

anti-aliasing The smoothing of jagged edges on diagonal lines created in an imaging program, by giving intermediate values to pixels between the steps.

application (program) Software designed to make the computer perform a specific task. So, image-editing is an application, as is word-processing. System software, however, is not an application, as it controls the running of the computer.

artifact A flaw in a digital image.

ASIC (Application-Specific Integrated Circuit) A silicon chip that is dedicated to one particular function, such as to graphics processing, or to a specific program, such as Photoshop. Used in an accelerator board, this is a fast solution, but it has limited uses.

aspect ratio The ratio of the height to the width of an image, screen, or page.

backup A copy of either a file or a program, for safety reasons, in case the original becomes damaged or lost. The correct procedure for making backups is on a regular basis, while spending less time making each one than it would take to redo the work lost.

banding Unwanted effect in a tone or color gradient in which bands appear instead of a smooth transition. It can be corrected by higher resolution and more

steps, and by adding noise to confuse that part of the image. *See also* NOISE FILTER

Bézier curve A curve described by a mathematical formula. In practice, it is produced by manipulating control handles on a line that is partly held in place by anchor points.

bit (binary digit) The basic data unit of binary computing. *See also* BYTE

bit depth The number of bits-per-pixel (usually per channel, sometimes for all the channels combined), which determines the number of colors it can display. Eight bits-per-channel are needed for photographic-quality imaging.

bitmap (bitmapped image) Image composed of a pattern of pixels, as opposed to a mathematically defined object (an object-oriented image). The more pixels used for one image, the higher its resolution. This is the normal form of a scanned photograph. *See also* OBJECT-ORIENTED (IMAGE)

brightness The level of light intensity. One of the three dimensions of color. *See also* HUE *and* SATURATION

buffer An area of temporary data storage, normally used to absorb differences in the speed of operation between devices. For instance, a file can usually be sent to an output device, such as a printer, faster than that device can work. A buffer stores the data so that the main program can continue operating.

byte Eight bits—the basic data unit of desktop computing. *See also* BIT

cache An area of information storage set aside to keep frequently needed data readily available. This allocation speeds up operation.

calibration The process of adjusting a device, such as a monitor, so that it works consistently with others, such as scanners and film recorders.

CCD (Charge-Coupled Device) A tiny photocell, made more sensitive by carrying an electrical charge before it is exposed. Used in densely packed arrays, CCDs are the recording medium in low- to medium-resolution scanners and in digital cameras.

CD-R (Compact Disc-Recordable) A writable cd-rom. Designed for desktop production using a

relatively small recorder, CD-R discs look like ordinary cd-roms and are compatible with cd-rom drives, but have a different internal structure. They can be used as high-volume removable storage (700MB), and for producing multimedia projects and portfolios.

CGM (Computer Graphics Metafile) Image file format for both bitmapped and object-oriented images.

channel Part of an image as stored in the computer; similar to a layer. Commonly, a color image will have a channel allocated to each primary or process color, and sometimes one or more for a mask or other effect. *See also* ALPHA CHANNEL

clipboard Part of the memory used to store an item temporarily when being copied or moved. *See also* CUT-AND-PASTE

cloning In an image-editing program, the process of duplicating pixels from one part of an image to another.

CMOS (Complementary Metal-Oxide Semiconductor) Energy-saving design of semiconductor that uses two circuits of opposite polarity. Pioneered in digital cameras by Canon.

CMS (Color Management System) Software (and sometimes hardware) that ensures color consistency between different devices, so that at all stages of image-editing, from input to output, the color balance stays the same. *See also* PANTONE

CMYK (Cyan, Magenta, Yellow, Key) The four process colors used for printing, including black (key).

color depth *See also* BIT DEPTH

color g amut The range of color that can be produced by an output device, such as a printer, a monitor, or a film recorder.

color model A system for describing the color gamut, such as RGB, CMYK, HSB, and lab.

color separation The process of separating an image into the process colors cyan, magenta, yellow, and black (CMYK), in preparation for printing.

color space A model for plotting the hue, brightness, and saturation of color.

compression Technique for reducing the amount of space that a file occupies, by removing redundant data.

continuous-tone image An image, such as a photograph, in which there is a smooth progression of tones between black and white. *See also* HALFTONE IMAGE

contrast The range of tones across an image from highlight to shadow.

cropping Delimiting an area of an image.

database A collection of information stored in the computer in such a way that it can be retrieved to order—the electronic version of a card index kept in filing cabinets. Database programs are one of the main kinds of application software used in computers.

default The standard setting or action used by a computer unless deliberately changed by the operator.

densitometer Software tool for measuring the density (brightness/darkness) of small areas of an image, monitor or photograph.

dialog box An on-screen window, part of a program, for entering settings to complete a procedure.

dithering The technique of appearing to show more colors than are actually being used, by mingling pixels. A complex pattern intermingling adjacent pixels of two colors gives the illusion of a third color, although this gives a much lower resolution.

DMax (Maximum Density) The maximum density—that is, the darkest tone—that can be recorded by a device.

DMin (Minimum Density) The minimum density—that is, the brightest tone—that can be recorded by a device.

dpi (dots-per-inch) A measure of resolution in halftone printing. *See also* PPI

draw(ing) program Object-oriented program for creating artwork, as distinct from painting programs that are pixel-based.

dye sublimation printer A color printer that works by transferring dye images to a substrate (paper, card, etc.) by heat, to give near photographic-quality prints.

dynamic range The range of tones that an imaging device can distinguish, measured as the difference between its dmin and dmax. It is affected by the sensitivity of the hardware and by the bit depth.

EPS (Encapsulated PostScript) Image file format developed by Alsys for PostScript files for object-oriented graphics, as in draw programs and page layout programs. *See also* OBJECT-ORIENTED IMAGE *and* DRAW(ING) PROGRAM

fade-out The extent of any graduated effect, such as blur or feather. With an airbrush tool, for example, the fade-out is the softness of the edges as you spray.

feathering Digital fading of the edge of an image.

filter Imaging software included in an image-editing program that alters some image quality of a selected area. Some filters, such as Diffuse, produce the same effect as the optical filters used in photography after which they are named; others create effects unique to electronic imaging.

fringe A usually unwanted border effect to a selection, where the pixels combine some of the colors inside the selection and some from the background.

gamma A measure of the contrast of an image, expressed as the steepness of the characteristic curve of an image.

global correction Color correction applied to the entire image.

graphics tablet A flat rectangular board with electronic circuitry that is sensitive to the pressure of a stylus. Connected to a computer, it can be configured to represent the screen area and can then be used for drawing.

grayscale A sequential series of tones, between black and white.

GUI (Graphic User Interface) Screen display that uses icons and other graphic means to simplify using a computer. The Macintosh GUI was one of the reasons for Apple's original success in desktop computing.

halftone image An image created for printing by converting a continuous-tone image into discrete dots of varying size. The number of lpi (lines-per-inch) of the dot pattern affects the detail of the printed image.

handle Icons used in an object-oriented draw program which, when selected with the cursor, can be used to manipulate a picture element. They usually appear on-screen as small black squares. *See also* DRAW(ING) (PROGRAM) *and* OBJECT-ORIENTED (IMAGE, PROGRAM)

HDRi (High Dynamic Range imaging) Software-based process that combines a number of images taken at different exposure settings to produce an image with full shadow to highlight detail.

histogram A map of the distribution of tones in an image, arranged as a graph. The horizontal axis is in 256 steps from solid to empty, and the vertical axis is the number of pixels.

HSB (Hue, Saturation and Brightness) The three dimensions of color. One kind of color model.

hue A color defined by its spectral position; what is generally meant by "color" in lay terms.

icon A symbol that appears on-screen to represent a tool, file, or some other unit of software.

image compression A digital procedure in which the file size of an image is reduced by discarding less important data.

image-editing program Software that makes it possible to enhance and alter a scanned image.

image file format The form in which an image is handled and stored electronically. There are many such formats, each developed by different manufacturers and with different advantages according to the type of image and how it is intended to be used. Some are more suitable than others for high-resolution images, or for object-oriented images, and so on. *See also* BMP, CGM, PCD, PICT, SCITEX CT *and* TIFF

imagesetter A high-resolution optical device for outputting images on film or paper suitable for reproduction from a digital file.

indexed color A digital color mode in which the colors are restricted to 256, but are chosen for the closest reproduction of the image or display.

interpolation Bitmapping procedure used in resizing an image to maintain resolution. When the number of pixels is increased, interpolation fills in the gaps by comparing the values of adjacent pixels.

inkjet Printing by spraying fine droplets of ink onto the page; by some distance the most common home printing technology.

ISO (International Standards Organization) The body that defines design, photography, and publishing elements.

JPEG (Joint Photographic Experts Group) Pronounced "jay-peg," a system for compressing images, developed as an industry standard by the International Standards Organization. Compression ratios are typically between 10:1 and 20:1, although lossy (but not necessarily noticeable to the eye).

Lab, L*a*b* A three-dimensional color model based on human perception, with a wide color gamut.

lasso A selection tool used to draw an outline around an area of the image.

layer One level of an image file, separate from the rest, allowing different elements to be edited separately.

LCD (Liquid Crystal Display) Flat screen display used in digital cameras and some monitors. A liquid-crystal solution held between two clear polarizing sheets is subject to an electrical current, which alters the alignment of the crystals so that they either pass or block the light.

lossless Type of image compression in which no information is lost, and so most effective in images that have consistent areas of color and tone. For this reason, not so useful with a typical photograph.

lossy Type of image compression that involves loss of data, and therefore of image quality. The more compressed the image, the greater the loss.

lpi (lines-per-inch) Measure of screen and printing resolution. See also PPI

luminosity Brightness of color. This does not affect the hue or color saturation.

LZW (Lempel-Ziv-Welch) A lossless compression process used for bitmapped images using at least a 2:1 ratio.

macro A single command, usually a combination of keystrokes, that sets in motion a string of operations. Used for convenience when the operations are run frequently.

mask A grayscale template that hides part of an image. One of the most important tools in editing an image, it is used to make changes to a limited area. A mask is created by using one of the several selection tools in an image-editing program; these isolate a picture element from its surroundings, and this selection can then be moved or altered independently. See also ALPHA CHANNEL and SELECTION

mid-tone The parts of an image that are approximately average in tone, midway between the highlights and shadows.

mode One of a number of alternative operating conditions for a program. For instance, in an image-editing program, color and grayscale are two possible modes.

noise Random pattern of small spots on a digital image that are generally unwanted, caused by non-image-forming electrical signals.

noise filter Imaging software that adds noise for an effect, usually either a speckling or to conceal artifacts such as banding. See also ARTIFACT and NOISE

Pantone Pantone Inc.'s color system. Each color is named by the percentages of its formulation and so can be matched by any printer. See also CMYK and CMS (COLOR MANAGEMENT SYSTEM)

pixel (PICture ELement) The smallest unit of a digitized image—the square screen dots that make up a bitmapped picture. Each pixel carries a specific tone and color.

plugin module Software produced by a third party and intended to supplement a program's performance.

PNG (Portable Network Graphic) A file format designed for the web, offering compression or indexed color. Compression is not as effective as JPEG.

PostScript The programming language that is used for outputting images to high-resolution printers, originally developed by Adobe.

ppi (pixels-per-inch) A measure of resolution for a bitmapped image.

processor A silicon chip containing millions of micro-switches, designed for performing specific functions in a computer or digital camera.

program A list of coded instructions that makes the computer perform a specific task. See also SOFTWARE

RAID (Redundant Array of Independent Disks) A stack of hard disks that function as one, but with greater capacity.

RAM (Random Access Memory) The working memory of a computer, to which the central processing unit (cpu) has direct, immediate access.

real-time The appearance of instant reaction on the screen to the commands that the user makes—that is, no appreciable time-lag in operations. This is particularly important when carrying out bitmap image-editing, such as when using a paint or clone tool.

Res (RESolution) Abbreviation used for metric resolution. Thus, "Res 12" is 12 lines-per-millimeter.

resampling Changing the resolution of an image either by removing pixels (lowering resolution) or adding them by interpolation (increasing resolution).

resolution The level of detail in an image, measured in pixels (e.g. 1024 by 768 pixels), lines-per-inch (on a monitor) or dots-per-inch (in the halftone pattern produced by a printer, e.g. 1200 dpi).

RGB (Red, Green, Blue) The primary colors of the additive model, used in monitors and image-editing programs.

rubber-stamp A paint tool in an image-editing program that is used to clone one selected area of the picture onto another. It allows painting with a texture rather than a single tone/color, and is particularly useful for extending complex textures such as vegetation, stone, and brickwork.

saturation The purity of a color; absence of gray, muddied tones.

selection A part of the on-screen image that is

chosen and defined by a border, in preparation for making changes to it or moving it.

SLR (Single Lens Reflex) A camera which transmits the same image via a mirror to the film and viewfinder.

software Programs that enable a computer to perform tasks, from its operating system to job-specific applications such as image-editing programs and third-party filters.

stylus Penlike device used for drawing and selecting, instead of a mouse. Used with a graphics tablet.

submarining Screen display fault in which the cursor temporarily disappears when moved.

subtractive primary colors The three colors cyan, magenta, and yellow, used in printing, which can be combined to create any other color. When superimposed on each other (subtracting), they produce black. In practice a separate black ink is also used for better quality. *See also* RGB *and* ADDITIVE PRIMARY COLORS

thumbnail Miniature on-screen representation of an image file.

TIFF (Tagged Image File Format) A file format for bitmapped images. It supports CMYK, RGB, and grayscale files with alpha channels, and lab, indexed-color, and it can use LZW lossless compression. It is now the most widely used standard for good-resolution digital photographic images.

tiling A method of creating or reproducing a large image area by adding adjacent sections all in the same basic shape, usually a square. For instance, a texture can be extended across the entire screen by copying a small square of the texture and joining up the copies. One essential is that the joins are seamless, to give the appearance of being continuous.

tool A program specifically designed to produce a particular effect on-screen, activated by choosing an icon and using it as the cursor. In image-editing, many tools are the equivalents of traditional graphic ones, such as a paintbrush, pencil, or airbrush.

toolbox A set of programs available for the computer user, called tools, each of which creates a particular on-screen effect. *See also* TOOL

TTL (Through-The-Lens meter) A device that is built into a camera to calculate the correct exposure based on the amount of light coming through the lens.

upgrade Either a new version of a program or an enhancement of hardware by addition.

USB (Universal Serial Bus) In recent years this has become the standard interface for attaching devices to the computer, from mice and keyboards to printers and cameras. It allows "hot-swapping," in that devices can be plugged and unplugged while the computer is still switched on.

USM (Unsharp Mask) A sharpening technique achieved by combining a slightly blurred negative version of an image with its original positive.

vector graphic Computer image in which the stepping effect of bitmapping is removed to give smooth curves. *See also* OBJECT-ORIENTED (PROGRAM)

virtual memory The use of free space on a hard drive to act as temporary (but slow-to-access) memory.

WiFi A wireless connectivity standard, commonly used to connect computers to the Internet via a wireless modem or router.

wysiwyg (what you see is what you get) Pronounced "wizzywig," this acronym means that what you see on the screen is what you get when you print the file.

Index

Acknowledgments

This book is dedicated to my mother and father, my brother Allan and his family. Special thanks go to the kind man who allowed me to use his jetty to photograph Grasmere. That morning put me in the mood to sit on a rock by the lakeside and begin writing the book on my iPad (its final words were typed in a noisy south London pub). Also to Peter Schmeichel and Don McCullin.

JOHN BEARDSWORTH